S0-BRM-082

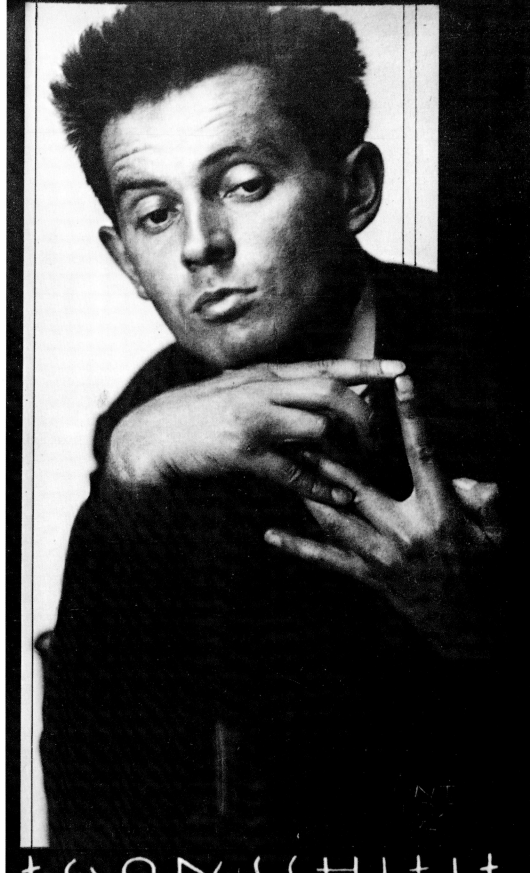

EGON SCHIELE

Klaus Albrecht Schröder

Egon Schiele

Eros and Passion

Prestel

Munich · New York

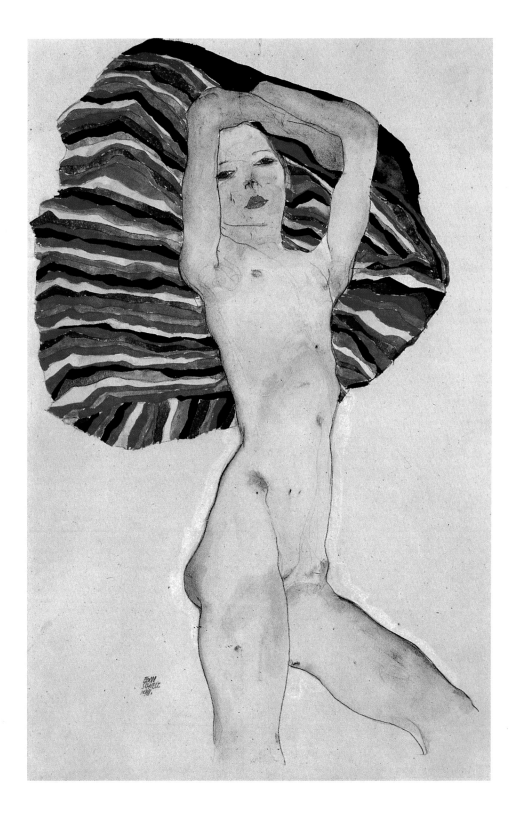

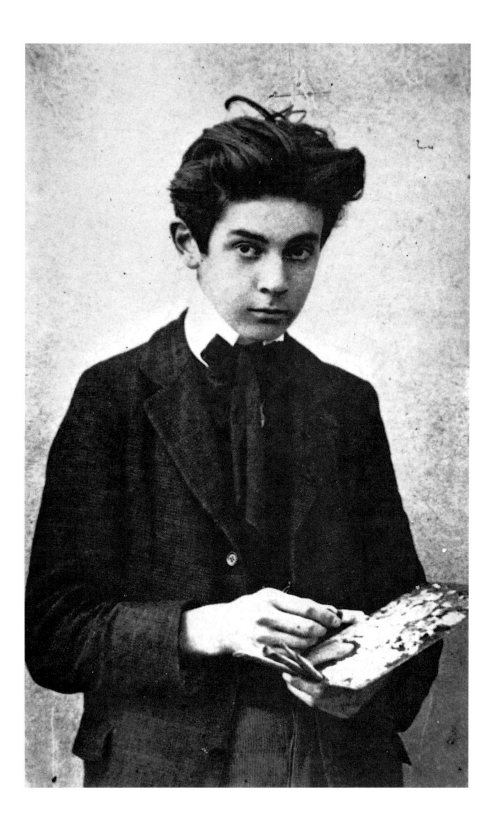

Biographical Notes

1890

Egon Schiele was born on June 12, the third child of a railroad controller, Adolf Eugen Schiele (1850-1905), and of his wife Marie, née Soukoup (1862-1935), at Tulln, a small town on the Danube in Lower Austria. Of the six children of the marriage only three survived infancy: Egon grew up alongside his sisters Melanie (1886-1974) and Gertrude (1894-1981).

1896-1905

Schiele attended elementary school at Tulln and then transferred to the Realgymnasium (high school) in Krems. In 1902 his lack of progress there led his father to move him again to the Landes-Real- und Ober-Gymnasium in Kloster-

Egon around 1895 with his younger sister Gertrude, whom he was often to paint

Opposite: Egon aged 15 with palette

Tulln railroad station, where Schiele was born

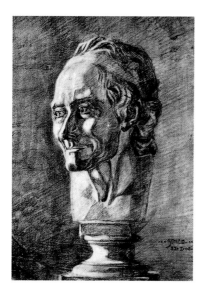

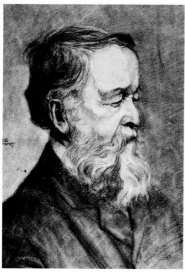

Plaster Cast of Houdon's Bust of Voltaire,
1906. Charcoal on paper, 20 ⅝ x 14 ⅞ in.
(52.5 x 37.8 cm). Graphische Sammlung
Albertina, Vienna

Bust of a Bearded Man Facing Right, 1907
Charcoal on paper, 21 x 14 ⅞ in.
(53.2 x 37.9 cm). Graphische Sammlung
Albertina, Vienna

neuburg. Schiele's childhood was overshadowed by the illness of his father, who died on New Year's Day, 1905. His uncle and godfather, the engineer Leopold Czihaczek (1842-1929), was made his guardian. Czihaczek hoped that his ward would later study at the Technische Hochschule (Institute of Technology) in Vienna.

At his second high school, Schiele became friendly with his drawing teacher, Ludwig Karl Strauch (1875-1959), who also gave him private lessons, and with the Klosterneuburg painter Max Kahrer (1878-1937). In 1905-1907 he produced over a hundred paintings, mainly landscapes. Making little progress at high school, he was withdrawn at an early age. His manifest talent for drawing already pointed to an artistic career.

1906

In October Schiele passed the entrance examination to the Akademie der bildenden Künste (Academy of Fine Arts) in Vienna. There he joined the general painting class of Christian Griepenkerl (1839-1916), one of the principal exponents of the academic *Ringstrasse* school of Viennese painting.

1907-1908

In 1907 Schiele succeeded in making the acquaintance of Gustav Klimt (1862-1918). In the same year, the seventeen-year-old art student took his twelve-year-old sister Gertrude on a trip to Trieste, where he made studies of harbor subjects. In Vienna

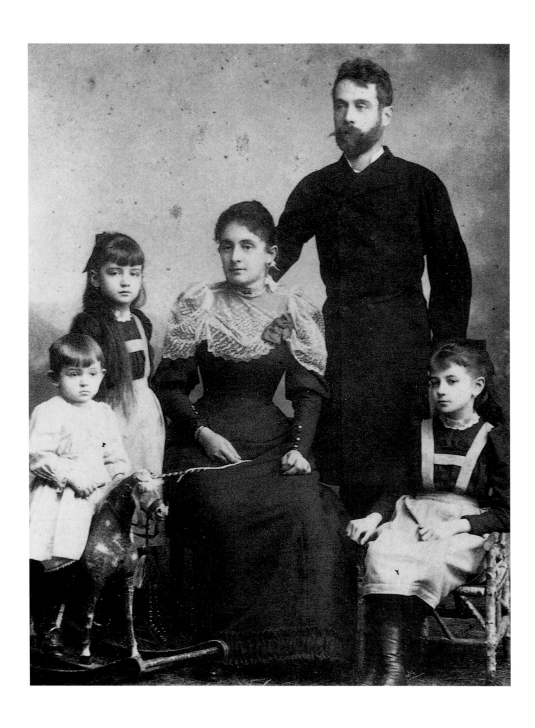

The young Schiele with his parents and two
older sisters, Melanie and Elvira, ca. 1894

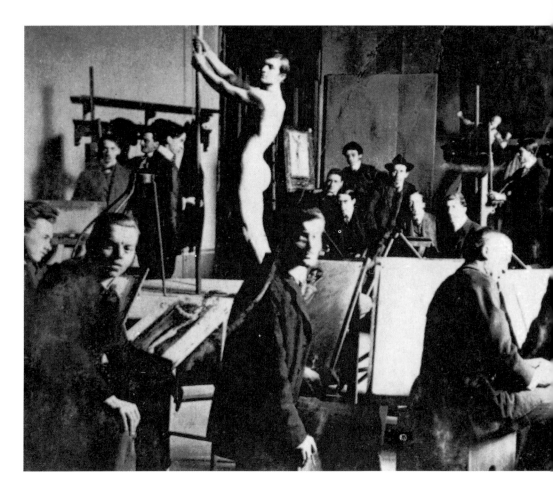

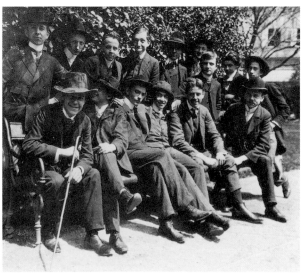

Life class at the Academy in Vienna 1907.
Schiele is standing at the rear, left of
center, next to the man wearing a hat.

Schiele (back row, second from right)
with fellow members of the painting class
at the Academy in Vienna, 1907.

he moved into a studio of his own, Kurzbauergasse 6, Vienna II. In 1908 Schiele took part in a public exhibition for the first time, in the Kaisersaal of the monastery of Klosterneuburg.

1909

Schiele and a number of his classmates (Albert Paris von Gütersloh, Anton Faistauer, Sebastian Isepp, Franz Wiegele, and others) set up the Neukunstgruppe (New Art Group) and walked out of the Academy in protest against the teaching of Griepenkerl and the traditional syllabus.

In December the Neukunstgruppe held its first exhibition, in the Salon of the art dealer Gustav Pisko in Vienna. There, Schiele met Arthur Roessler (1877-1955), author and art critic of the *Arbeiter-Zeitung*, the collectors Carl Reininghaus (1857-1929) and Dr. Oskar Reichel, and the publisher Eduard Kosmack (1880-1947).

Four works by Schiele were included in the *Internationale Kunstschau Wien 1909* (International Art Show, Vienna 1909), under the presidency of Klimt; all four showed a strong affinity with Klimt's style.

Working alongside his friend Max Oppenheimer (1885-1954; the friendship did not last), Schiele moved away from decorative Jugendstil and towards Expressionism. In 1909 he wrote a number of Expressionistic prose-poems.

Self-Portrait with Hands on Chest, 1910
Charcoal, watercolor, and gouache on paper,
17 ⅝ x 12 ¼ in. (44.8 x 31cm).
Private collection

The artist's younger sister, Gertrude, who
often modeled for him, ca. 1909

Opposite: *Self-Portrait*, 1910
Black crayon, watercolor, and gouache,
17 ½ x 12 in. (44.3 x 30.6 cm).
Leopold Museum, Privatstiftung, Vienna

1910

At the suggestion of the architect
Otto Wagner, Schiele embarked on
a series of life-size portraits of well-
known Viennese personalities. The
project was never completed.

The Wiener Werkstätte (Vienna
Workshop) published three postcards
designed by Schiele. He exhibited
at the *Internationale Jagdausstellung*
(International Hunting Exhibition)
in Vienna as a member of the "Klimt
Group." He also exhibited in the
monastery at Klosterneuburg.

Schiele and his Academy friend,
the mime artist Erwin Osen, spent
the summer in Krumau (Český
Krumlov), his mother's home town.
Schiele and Osen shared an interest
in the bodily expression of disease:
in Vienna, Schiele made studies of
pregnant and sick women in the
clinic of the gynecologist Erwin von
Graff, and Osen visited the state
mental hospital, *Am Steinhof*, to
make sketches for a planned lecture
on "Pathological Expression in
Portraiture."

1911

The first monograph on Schiele's
work was published; its author was
the painter and poet Albert Paris
von Gütersloh. Arthur Roessler
analyzed Schiele's work in the
monthly art periodical *Bildende
Kunst*. In April-May, Schiele had
his first one-person show, at the
distinguished Galerie Miethke in
Vienna.

Schiele met Wally Neuzil, who
was to remain his girlfriend and his
favorite model until his marriage.
Together they moved to Krumau,

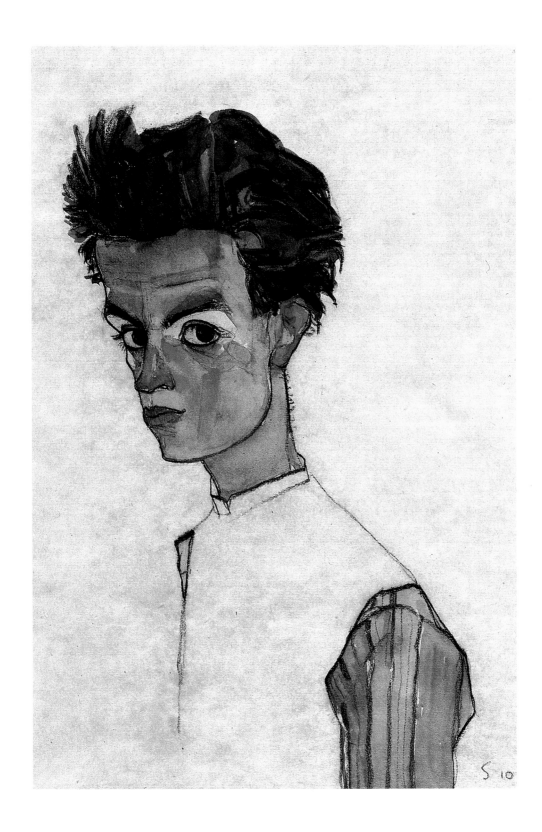

where an extremely productive artistic period began. The ancient town center of Krumau became a dominant theme of his painting. However, at the beginning of August, Schiele and Wally were expelled from Krumau. The residents may have taken exception to the fact that they were "living in sin," but the cause may also have been complaints over visits to the studio by children. After staying with his mother in Vienna for a short while, Schiele moved to Neulengbach, a small town near Vienna.

In September, through Roessler, Schiele established a connection with the Munich art dealer Hans Goltz.

1912

In the New Year, Schiele exhibited with the Neukunstgruppe at the Künstlerhaus (House of Artists) in Budapest. In Munich, his paintings were shown at the exhibition of the Munich Secession and at Goltz's gallery, together with works by members of the local group "Der blaue Reiter" (The Blue Rider), and his first print, a nude self-portrait lithograph, was issued in a collective portfolio by the Sema art association.

Here Schiele's burgeoning artistic career was rudely interrupted. His downfall was his habit of asking the neighbors' children to model for him. When Schiele and Wally Neuzil took in a thirteen-year-old girl runaway, the girl's father accused them of abduction. On April 13 Schiele was arrested at Neulengbach and held in custody, and on April 30 he was brought before the district

Photograph of Schiele by Anton J. Trčka, 1914

Schiele in his studio, 1916. The artist's copy of *The Blaue Reiter Almanac* can be seen in the cabinet on the left

Schiele and Wally Neuzil

court in St. Pölten. The main count against him—that of seducing a minor—was dropped; but, because children had been able to see nude studies in his studio, he was sentenced to three days' imprisonment for negligent custody of erotic nude material. In all, Schiele spent twenty-four days in jail.

In July, Schiele was represented in an exhibition of the Hagenbund (in Hagen, Westphalia) by seven oil paintings, including his large work *Hermits*, which shows him together with Klimt. Three of his works were shown in the important international Sonderbund exhibition in Cologne. In August Schiele traveled to Munich, Lindau, and Bregenz. In November he rented a studio at Hietzinger Hauptstrasse 101, in Vienna XIII, which he kept on until his death. Klimt put him in touch with his most important patron, the industrialist August Lederer.

1913

The Bund Österreichischer Künstler (League of Austrian Artists), with Klimt as its president, conferred membership on Schiele. In March he took part in the League's exhibition.

In Munich, his works were shown at the spring Secession exhibition and in the Galerie Goltz. His paintings were exhibited in Berlin and Düsseldorf. In Vienna, he took part in the *Internationale Schwarz-Weiss-Ausstellung* (International Black-and-White Exhibition) and the 43rd exhibition of the Vienna Secession.

During this year, Schiele again traveled a great deal: several times

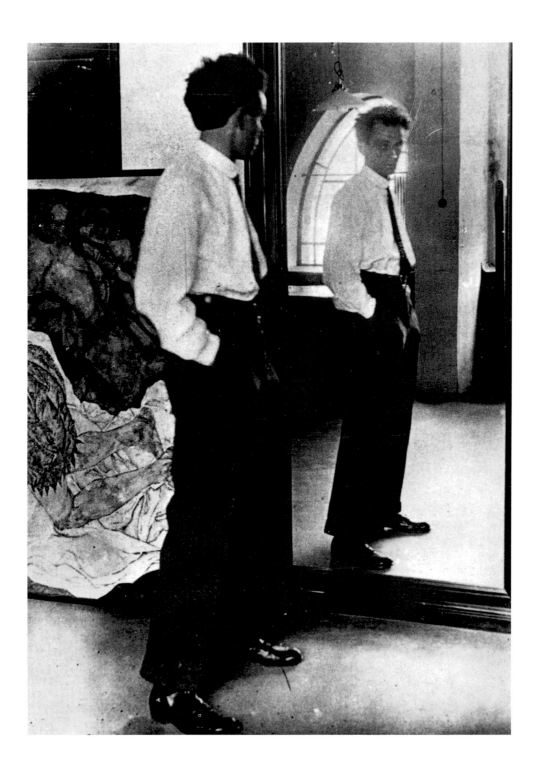

The artist in his studio, 1915

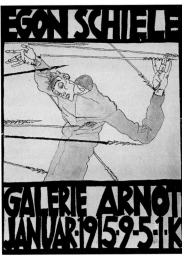

Egon Schiele, photograph by Johannes
Fischer, 1915

The artist's poster for his exhibition at the
Galerie Arnot, Vienna, 1915

to the Wachau area (where he paint-
ed views of Stein an der Donau), to
Krumau again, to Munich, to Villach,
and to Tarvis. He spent the summer
by Lake Traun and in Carinthia.

He became a contributor to the
Berlin periodical *Die Aktion*, which
was to bring out an Egon Schiele
special issue in 1916 (no. 35/36).

1914

On 28 July, Austria-Hungary de-
clared war on Serbia; general
mobilization followed on 31 July.

Schiele's exhibitions—an indicator
of his growing reputation—contin-
ued to grow both at home and
abroad. His work was shown in
Dresden, at the Hamburger Kunst-
verein, in the Munich Secession, and
at the Werkbund exhibition in Co-
logne. He also took part in exhibi-
tions in Rome, Brussels, and Paris.

In spite of this, Schiele continued
to live, as before, in straitened cir-
cumstances. It was not until the fall
of 1914 that he found his feet finan-
cially, thanks to the support of the
collector Heinrich Böhler.

Schiele discovered the artistic
potential of photography and pro-
duced a series of idiosyncratic por-
trait shots in collaboration with the
photographer Anton Josef Trčka
(1893-1940).

In November his favorite sister
Gertrude married his friend Anton
Peschka (1885-1940).

1915

In Vienna the Galerie Guido Arnot
gave Schiele a major one-man exhi-
bition, including 16 paintings and a

number of watercolors and drawings. His work was also exhibited at the Kunsthaus in Zurich. On June 17 Schiele married Edith Harms (1893-1918). Four days later he was drafted into the army and ordered to Prague. After basic training in Regiment 75, at Neuhaus (Jindřichův-Hradec) in Bohemia, he was assigned to Vienna on escort duty for Russian prisoners of war, some of whom he drew.

At the end of the year he was invited to exhibit at the Berlin Secession and the *Kunstschau* in Vienna.

1916

During the year Schiele was represented in the exhibitions of the Vienna Secession, at the Galerie Goltz in Munich, and at a *Graphikausstellung* (Prints and Drawings Exhibition) in Dresden.

From March 8 through September 30 he kept a war diary. In May he was transferred as a clerk to the Imperial-Royal Base for Officer Prisoners of War, at Mühling. There he made a number of drawings of Russian and Austrian officers. Leopold Liegler published an article on Schiele in the periodical *Die graphischen Künste*.

1917

In January, at his own request, Schiele was finally transferred to Vienna, to work at the K.K. Konsumanstalt (Imperial-Royal Post Exchange). He was commissioned to make drawings of Konsumanstalt warehouses and branch offices all over the Empire.

Edith Harms in the artist's studio

Photograph of Schiele by Anton J. Trčka, 1914

Opposite:
Postcard, overpainted and signed by the artist, 1914

Despite the limitations imposed by the war, Schiele pursued his artistic career. The bookseller Richard Lanyi published a portfolio of collotype facsimiles of Schiele's drawings and watercolors.

The plan for a communal effort by visual artists, writers and musicians to promote postwar cultural reconstruction by setting up a Kunsthalle (Hall of Art) foundered for lack of money. Schiele took part in exhibitions in Vienna, Munich, Amsterdam, Stockholm, and Copenhagen.

He succeeded in arranging for Klimt's *Beethoven Frieze*, which had been painted as an ephemeral piece of decor for a Secession exhibition, to be acquired by his own patron Lederer and thus saved from destruction.

1918

Klimt died on February 6. Schiele drew him on his deathbed. As Kokoschka had moved to Dresden in 1917, Schiele was now recognized as Austria's leading artist. The 49th exhibition of the Vienna Secession brought him his first major artistic and financial success. He exhibited 19 large paintings and 29 drawings. Franz Martin Haberditzl purchased the portrait *Edith Schiele Seated* for the Moderne Galerie, thus becoming the first and only Austrian museum director to buy a work by Schiele in the artist's lifetime.

At the end of April Schiele secured a transfer to the Imperial-Royal Army Museum, where his duties allowed time for his artistic work.

His works were shown with great success at the Kunsthaus, Zurich,

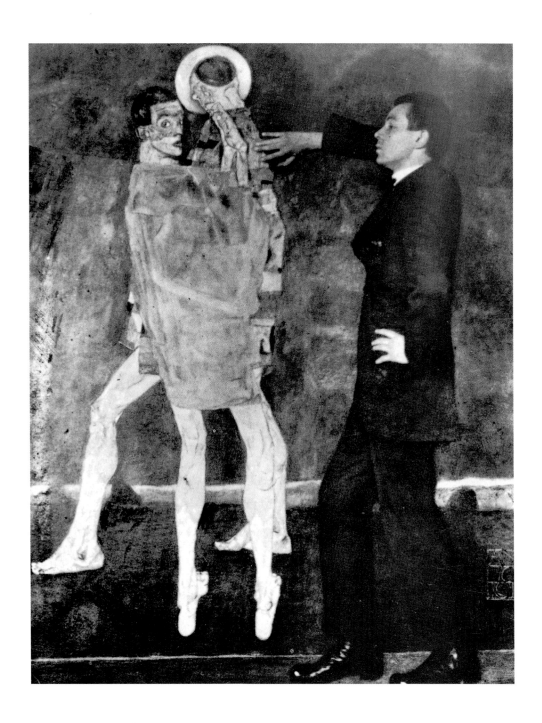

Schiele with his painting *Encounter* (lost), 1914

Opposite:
Egon and Edith Schiele in the summer of 1918

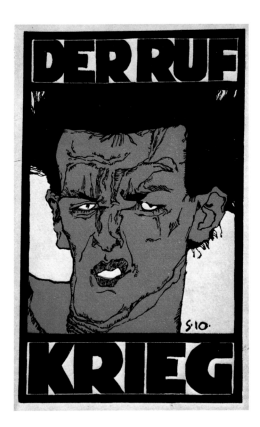

the Künstlerhaus Rudolphinum in Prague, and the Galerie Arnold in Dresden.

His financial success now permitted Schiele to rent a larger studio in Hietzing, at Wattmanngasse 6. The old studio was to be used for a new art school.

In the last days of the war, his wife Edith contracted the deadly Spanish Influenza that was raging in Vienna as it was all over Europe; she was six months pregnant. She died on October 28. Schiele outlived his wife by only three days; he died in the early morning of October 31. Martha Fein photographed him on his deathbed, and Anton Sandig took a death mask. On November 3 he was buried in the cemetery at Ober St. Veit.

On November 3, Austria-Hungary signed an armistice and agreed to capitulate unconditionally.

Title page of the periodical *Der Ruf*, showing a self-portrait (1910) by Schiele

Opposite:
Letter of August 9, 1913 from Schiele to Arthur Roessler

8. August 1913.

Lieber Herr Dr. Röpke!

Wie geht es Ihnen in Altmünster?
[...]
Wir wohnen in
einem [...]
[...] Zimmer und
Küche, einen großen gedeck-
ten [...] Raum, ein
eigenes Boot mit Boots-
[...]
[...] auf 150 K und hätte 200 K
für den ganzen Sommer
gekostet. — Kommt es auch?
— Hier ist es ganz prächtig,
[...]

und haben daher die Hefte originell sehr viel
gute eigenschaften, vorallem ist sonnig-farbig.
Wen sind die fotos aufgefallen? Bin
schon sehr neugierig. Es laid mit mir
und daß ich nach Hallstadt
nicht kann.

Mit herzlichen Grüssen
aus Tirol
 juck Kunstreise
von der geistigen
Frau

24

Paintings and Works on Paper

1910-1917

Self-Portrait with Bare Shoulder, 1912
Oil on panel, 16 ½ x 13 ⅜ in.
(42 x 34 cm). Leopold Museum,
Privatstiftung, Vienna

Seated Female Nude with Raised Right Arm (Gertrude Schiele), 1910

Standing Nude (Gertrude Schiele), 1910

Naked Girl, Reclining, 1911

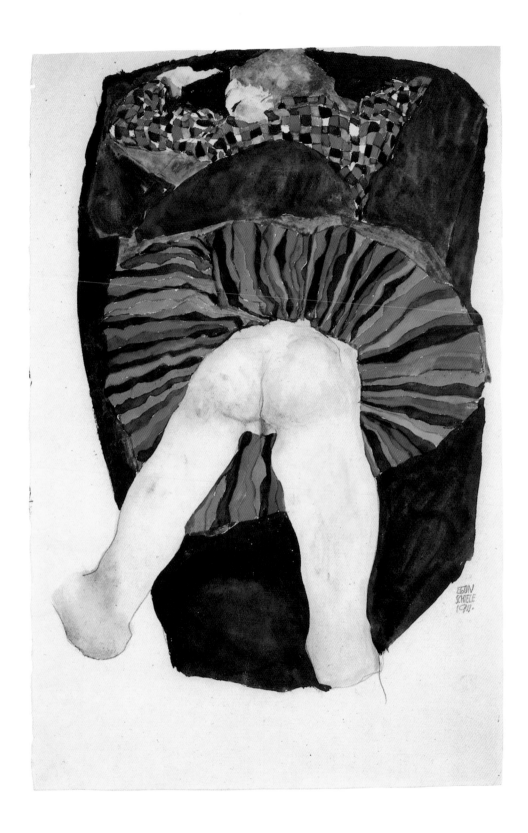

Reclining Seminude, 1911

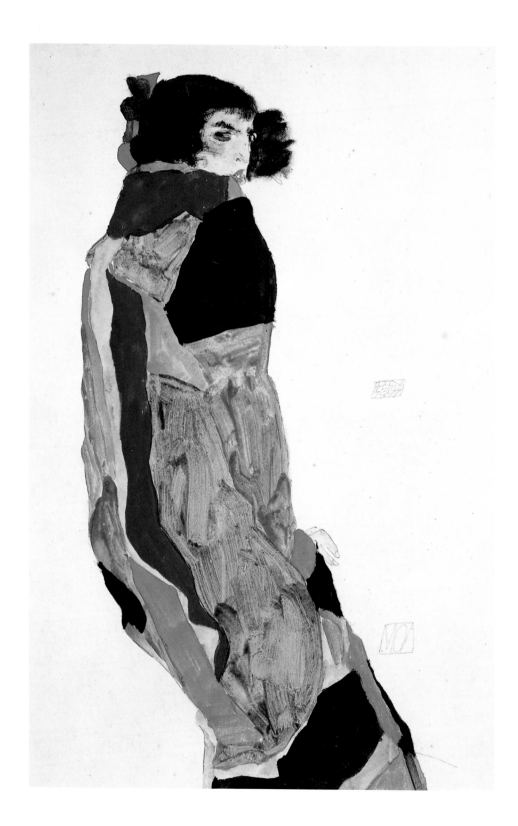

The Dancer Moa, 1911

Crouching Female Nude, Bending Forward, 1912

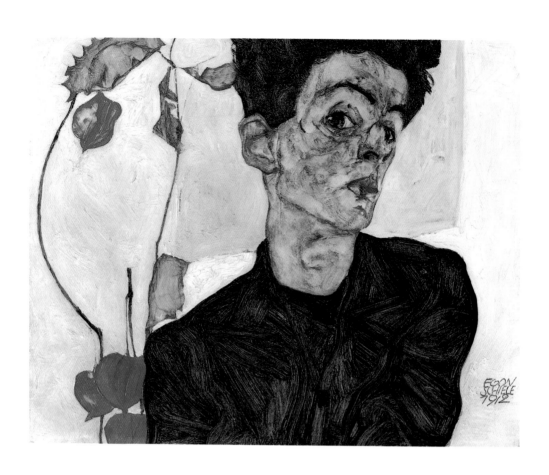

Self-Portrait with Chinese Lantern Plant, 1912

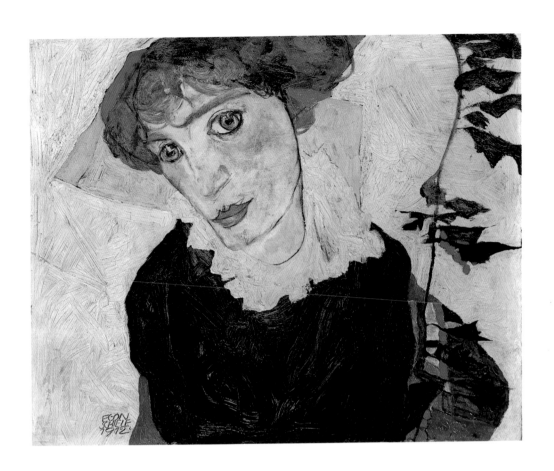

Portrait of Valerie Neuzil, 1912

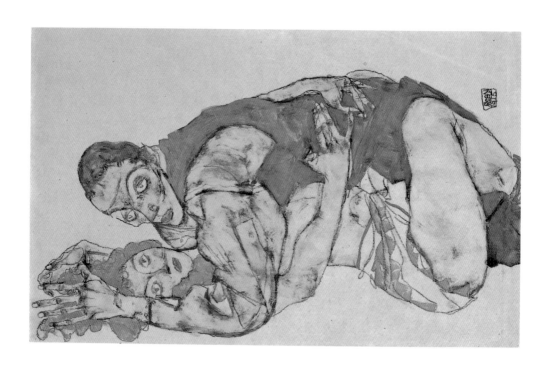

Coitus, 1915

34

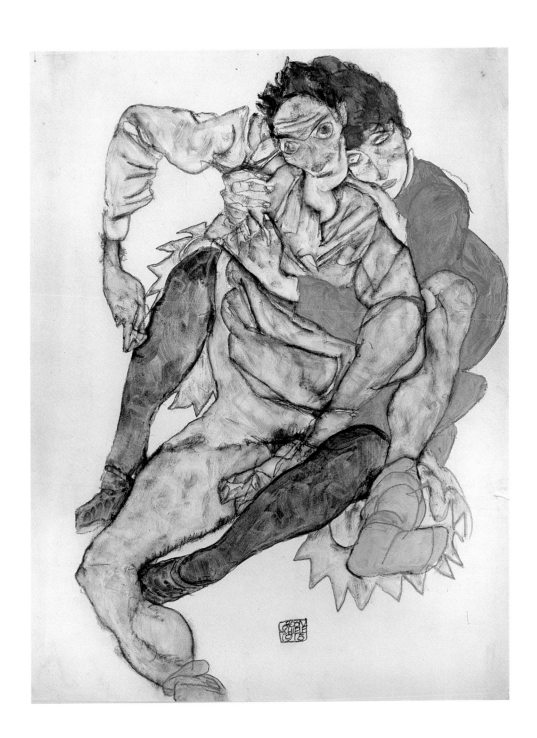

Seated Couple (Egon and Edith Schiele), 1915

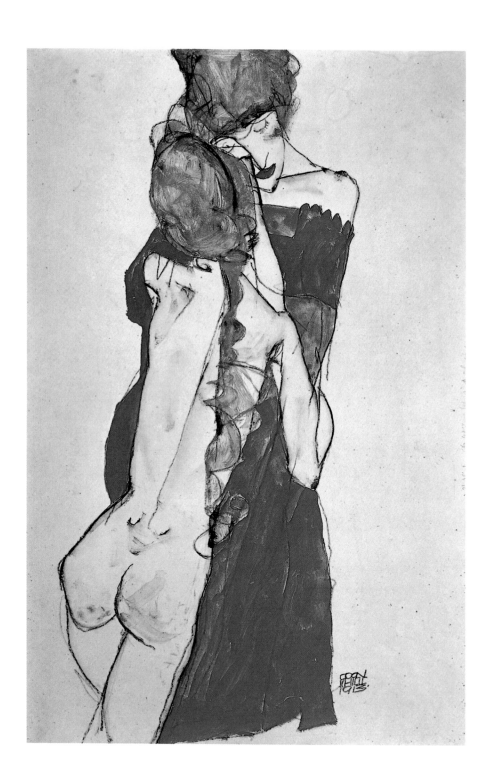

Mother and Child, 1913

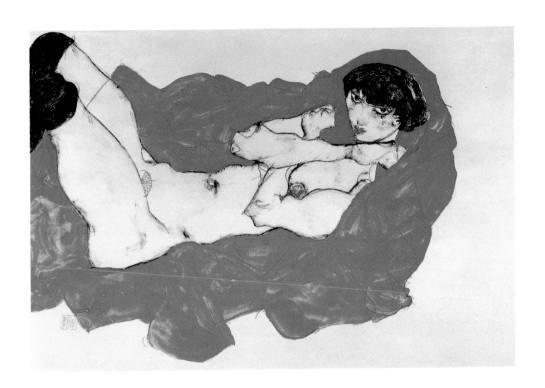

Reclining Female Nude on Red Drape, 1914

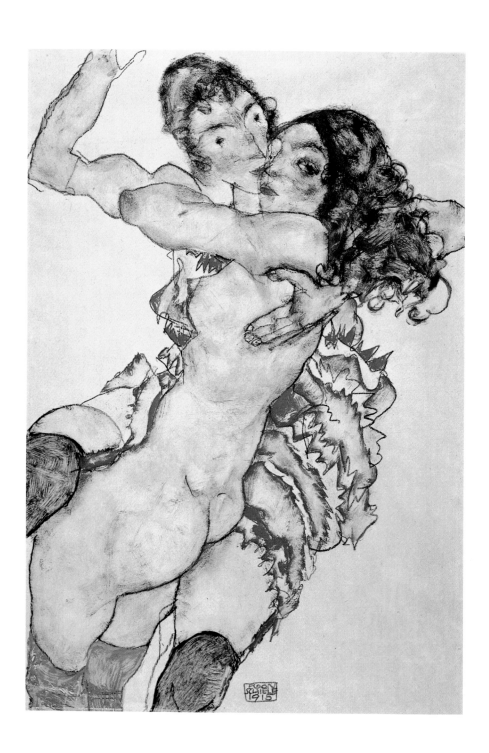

Two Girls Embracing (Two Friends), 1915

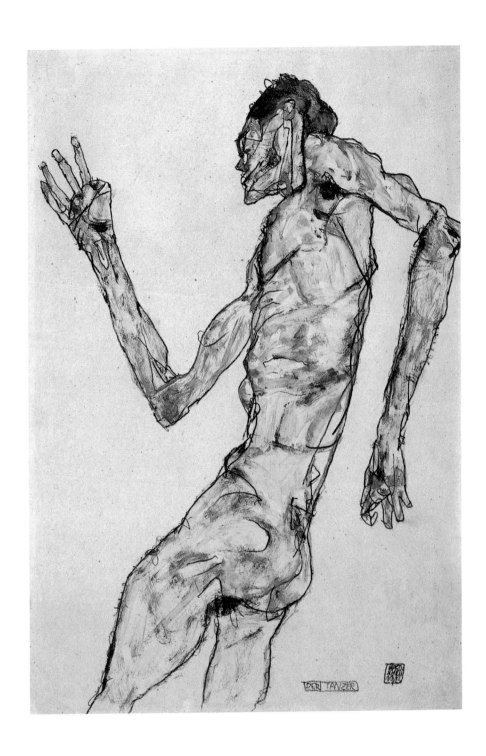

The Dancer, 1913

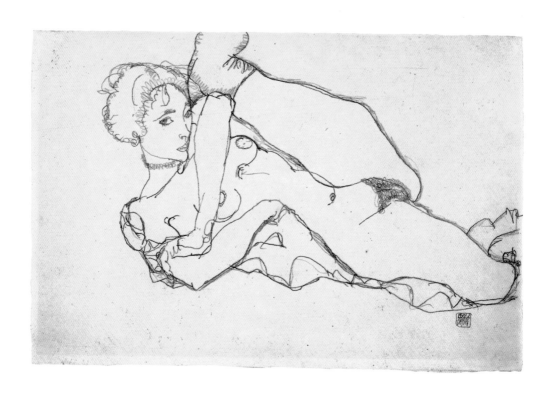

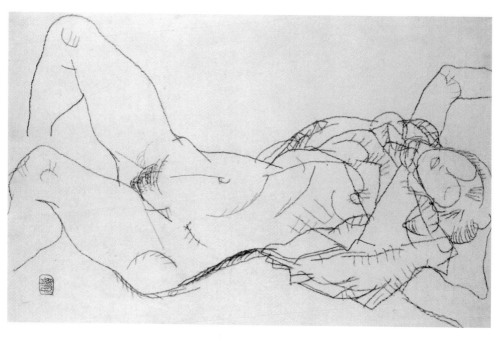

Reclining Nude with Left Leg Raised, 1914

Reclining Nude, 1914

40

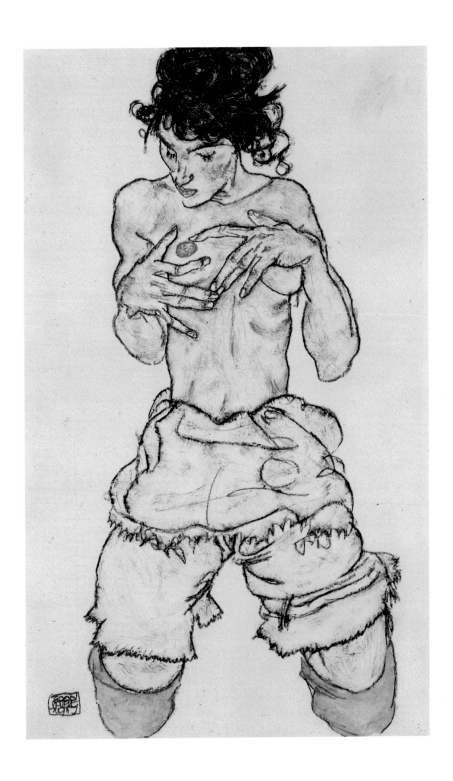

Kneeling Seminude, 1917

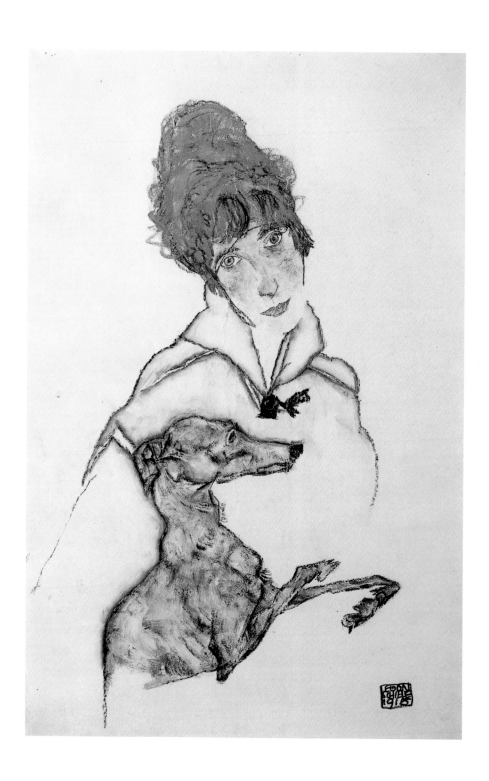

Woman with Greyhound (Edith Schiele), 1915

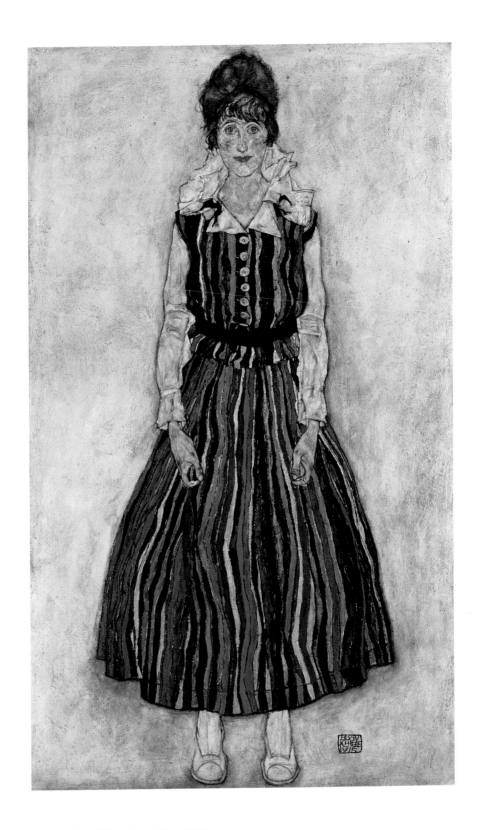

Portrait of Edith Schiele in Striped Dress, 1915

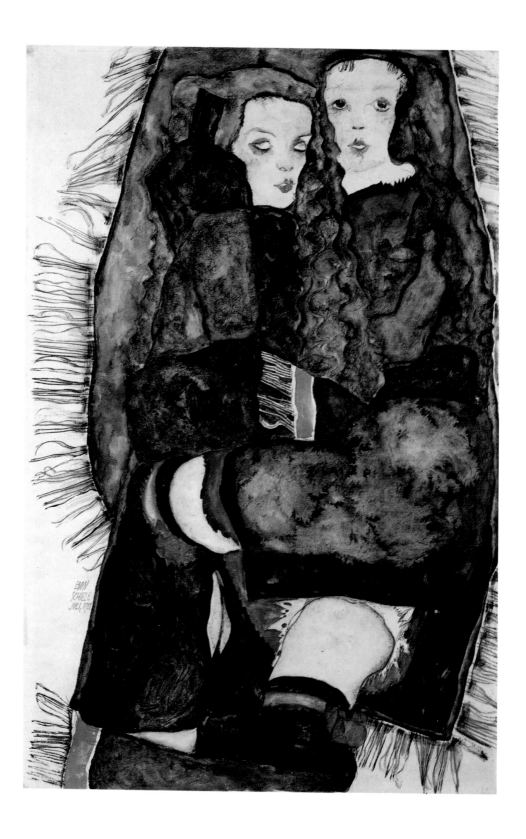

Affront to Decency

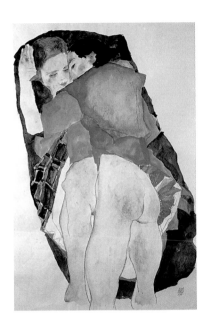

The modern world regards society and art as irreconcilable opposites. Art, by definition, is society's Other, the realm of its utter negation. Art must be critical, or it is not art; subversion is its standard, and deviation from the norm is its ideal. In a momentous chapter in the history of inwardness and subjectivity, Austrian Expressionism thrives on this mystical conflict: it proclaims that withdrawal from society is an implied act of defiance—or even that art itself is a violation of society's conventions and norms.

Social historians of art have seized on the incomprehension of the Viennese public as a perfect illustration of this conflict. Posterity is more attracted by the man who despised Oskar Kokoschka's work than by the man who bought it; and the judge who destroyed an Egon Schiele drawing on grounds of immorality is of more interest than his contemporary who collected "Schiele Erotica." Only posterity finds it easy to draw the distinction between pornography and (aesthetically tamed) eroticism. The fact is, however, that to look at a masturbating woman from a purely formal viewpoint is to ignore the historical context within which it was quite impossible to disregard the content of the image. Any contemporary of Schiele's was firmly trapped in a perceptual framework in which masturbation was defined as pathological, and in which the sight of forbidden homosexual love was held to be sexually arousing. That contemporary was likely to waver between the solitary gratification of voyeurism and the constantly endangered reassurance of regarding the erotic motif as legitimized by the institution of Art.

Not even the most painstaking efforts at historical reconstruction can turn us into Schiele's contemporaries. The primary act of consumption or enjoyment—which is a collective one, almost by definition—has been lost to us, as indeed has the tenuous pleasure that the male viewer of *Two Girls on a Fringed Blanket* derived from the breach of the taboo against Lesbian love.

In self-portraiture, things seem to have worked out differently. Schiele's self-portraits conduct a constantly renewed dialogue with the viewer. The implicit closeness is meant to leap the gulf of history that separates us from the artist. In all probability the world-view, lifestyle, mind-set, and beliefs of the Nuremberg patrician contemplating one of Albrecht Dürer's selfportrait

Two Girls (Lovers), 1911
Pencil, watercolor, and gouache on paper,
19 x 12 in. (48.3 x 30.5 cm). Private collection

Opposite:
Two Girls on a Fringed Blanket, 1911
Pencil, ink, watercolor, and gouache on paper,
22 x 14 ³/₈ in. (56 x 36.6 cm). Private collection

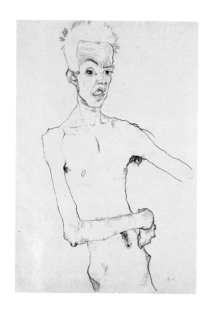

drawings are not much less remote from us than the
expectations of the Viennese viewer who recoiled from
the grimacing features of a self-portrait by Schiele.

But as we know, Schiele's erotic drawings, and his
grimacing self-portraits, still find an attentive response
from today's viewer. For all the vastness of the gulf
between viewing contexts then and now, they still hold
the eye as almost no other artistic genre can.

In his book on obscenity (subtitled "History of an
Indignation"), Ludwig Marcuse approached the ob-
scene through its effects:

> This is the lesson that we learn from a long history: a
> thing or person is obscene if he, she, or it has in some
> place, at some time, and for some reason, provoked indig-
> nation in someone. Only in the presence of indignation
> does the obscene become more than a phantom. . . .
> A specific indignation, best known through one of its
> favorite epithets, the abusive word "obscene," is aimed
> at the sexual realm and contiguous areas. [1]

However, pleasure fixed upon an objective reality is
regarded by the aesthete—or at least has been so re-
garded ever since art was released into its present state
of autonomy—as evidence of total artistic illiteracy: an
ordinary, everyday response to representations of nud-
ity, ugliness, or repulsiveness is considered as a failure
to recognize that art is an end in itself. By contrast,
Otto Dix once said that the *What* always precedes the
How and causes only the *What*. By this he meant that
the end product of nude figures is the very thing that
caused them to be made in the first place: the demands
of sexuality, the exhibitionist craving for sexual display.
The art critic Arthur Roessler, Schiele's patron and
journalistic ally, would be much misunderstood if he
were ever seen solely as a champion of the purifying
detachment that seeks to divorce the exhibitionistic,
narcissistic self-portrait or the obscene nude from the
viewer's own world of intimate experience. Roessler
wrote:

> To those who slaver and scold in hypocritical indignation
> over these works of Schiele, I would like to offer as food
> for thought an entry in Charles Baudelaire's journal, which
> runs as follows: "All those bourgeois imbeciles who con-
> stantly utter the words 'immoral,' 'immorality,' 'morality
> in art,' and other inanities, remind me of Louise Villedieu,

Self-Portrait with Open Mouth, 1910
Black crayon on paper, 17 ⅞ x 12 ⅜ in.
(45.5x 31.4 cm). Private collection

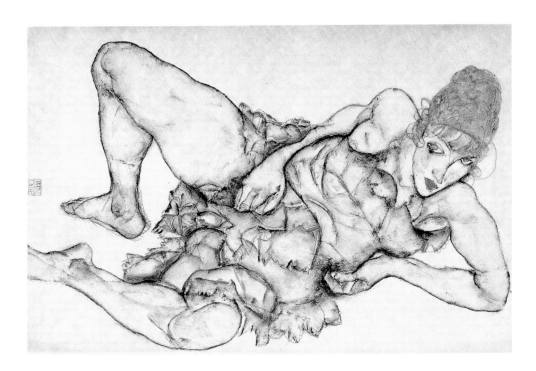

Reclining Woman with Blonde Hair, 1914
Pencil, watercolor, and gouache on paper,
12 ½ x 19 ⅛ in. (31.7 x 48.5 cm).
The Baltimore Museum of Art

a five-franc whore whom I once took to the Louvre. She started to blush, constantly tugged at my sleeve, hid her face, and asked me, in the presence of immortal statues and paintings, how anyone could possibly exhibit such indecencies in public!" Anyone who sees in Schiele's works of art only the nakedness, only the obscene nakedness and nothing else, is past helping.[2]

Thus Roessler was not refusing to see the obscene nakedness. He simply wanted to hold Schiele's erotic art in suspense between the realistic closeness of its intimacy and the detachment of aesthetic contemplation.

There can be no doubt that in Schiele's time sexuality was *the* topic. From psychoanalysis by way of medicine to art, minds everywhere were concentrated on sex, whether with a view to its suppression or its emancipation. However—liberating though Schiele's offerings may have been in intention, if not in effect— we are not entitled to regard them as a pictorial war- cry from some cultural battlefield. To what extent Schiele's drawings of nudes were part of a pictorial industry catering to its customers' sexual needs, or to what extent they were autonomous works of art— categorically distinct from the cheap, mass-market

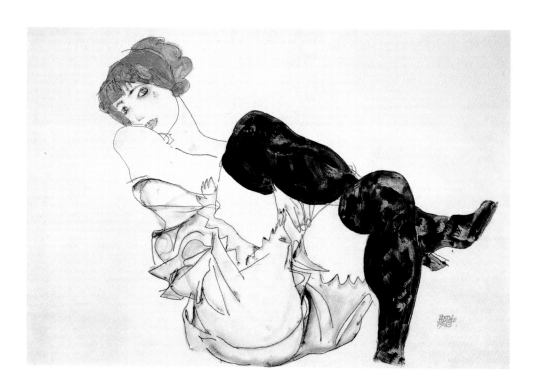

girlie photograph—is not, of course, an issue to be determined in terms of viewer response, even though the contemporary impact of the work was strictly under-the-counter. But nor is viewer response entirely irrelevant to the question of the "artworthiness" of the obscene nude.

Between 1870 and 1910, the way was paved for a revolution in the history of the portrait and of the nude; and this related directly to the new status of images of both face and body. In this, photography acted as the driving force of history; but there was much more to the process of reevaluation than is conveyed by stating that the naturalistically painted portrait was supplanted by the cheaper, more convenient, and more accurate technique of photography. What photography achieved, above all, was a leveling of the human image: everyone from exalted aristocrat to common criminal was now worth a picture from endless viewpoints. Photography became a means of identification. In the century-long struggle against the shaping of the nude body in accordance with the antique ideal of beauty, and in the struggle against the shaping of the portrait head in accordance with an ideal of mental and physical perfection, photography played an often-underestimated role.

Woman in Black Stockings (Valerie Neuzil), 1913
Pencil, watercolor, and gouache on paper,
12 ⅝ x 18 ⅞ in. (32.2 x 47.4 cm).
Private collection

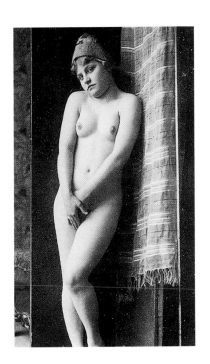

The new sciences of psychology and ethnology, and the teaching of medicine, created a huge demand for images of faces and bodies; in its zeal to define types and classify, psychopathology alone amassed vast photographic collections. And then there was the demand —no longer limited to a privileged section of society— for erotic pictures. No one photograph in isolation, but the totality of this unprecedented flood of human images constituted history's insidious revolt against the ideal of beauty as an end in itself. A norm that had held sway for centuries was redefined by reference to its outermost, pathological limits. The frontier was pushed back, and a supply of entirely new and pictorially preformed images of the human form was suddenly available. They were the decisive stylistic influence on Austrian Expressionism. Yet we should not consider the relationship between this new visual patrimony and later art in terms of "influence" pure and simple, on the lines of the shortest distance from A to B: motifs that originated in photography were totally reshaped and emancipated within a new context.

The importance of Viennese Art Nouveau (Jugendstil) in the creation of Schiele's structural, linear style has been exhaustively described, but so far insufficient light has been shed on the entirely new relationship in his work between image and body, or between image and face. Photography was the new source of pictorial production that offered the necessary available images. On the one hand, both erotic and psychiatric photography express a crisis of vision, a shift in the relationship between visible and invisible, between what is depictable and what is not; and, on the other hand, provided a springboard for Schiele's pictorial fantasy of the bodies of woman and man.

The Sweet Maid, erotic photography,
Vienna, ca. 1914. Private collection

Pain, the Great Muse

In 1910, Schiele painted and drew a series of self-portraits. In these he saw himself as an emaciated, ectomorphic, long-limbed body, spastic and hunch-backed, or with a rachitic deformation of the ribcage: this was the artist as an image of abject misery—a cripple. In watercolors and oil paintings alike, the dirty coloring, with its shrill accents, makes the flesh tones ugly and aberrant. In *Seated Male Nude*, a self-portrait, the artist mutates into an insect. The absence of the feet does not (as it would in a work by Auguste Rodin) imply a self-contained fragment: we take it literally and perceive it as an amputation. This is a mangled soul in a mangled body. We see through the body into the soul, as Roessler affirmed in a contemporary review:

> Schiele has seen and painted human faces that shimmer pallidly . . . and resemble the features of a vampire who craves his grisly sustenance; faces of the obsessed, whose souls fester; faces frozen by untold suffering into rigid masks; faces that subtly delineate the synthesis of an individual's inner life. . . . His ice-cold eyes have seen the livid hues of putrefaction in human faces, the death beneath the skin; and with untold wonderment he has gazed upon gnarled, contorted hands with nails of yellow horn.[3]

Whether explicitly or not, both the self-portrait and the nude are always seen in reference to their creator; they are not discussed in isolation from the biographical reality of the artist. More than any other, the art of the Austrian Expressionist "soul-rippers" (an epithet coined for Kokoschka) all too easily leads to a theory of authorship steeped in the notion of authenticity. In his self-portraits, Schiele shows himself as wrathful, with a look of spiritual vacancy; or as if racked by a severe spasm of hysteria; or arrogantly looking down his nose, with head tossed back; or apprehensively or naively peering out of the picture. Which Schiele is the real Schiele? If all of these self-dramatizations reveal the true nucleus of the painter's psyche, then he must have been a fragmented personality, unlikely to escape the diagnostic attentions of the genius of Sigmund Freud. The question is: just how much of his psyche is conveyed by his self-portraits, either those with grimaces or those that express a frozen resignation? What and whom does Egon Schiele really see in his studio

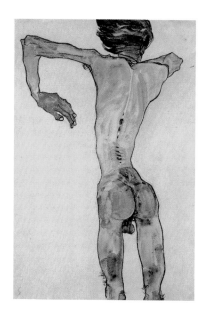

Standing Male Nude, Back View, 1910
Charcoal, watercolor, and gouache on paper, 17 ⅝ x 12 ⅛ in. (44.8 x 30.8 cm). Private collection

Opposite: *Seated Male Nude (Self-Portrait)*, 1910. Oil and gouache on canvas, 60 x 59 in. (152.5 x 150 cm). Leopold Museum, Privatstiftung, Vienna

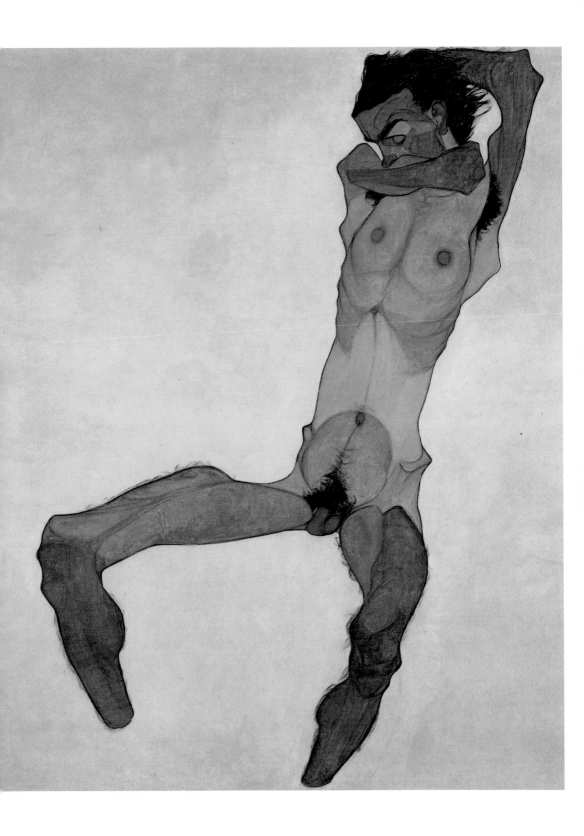

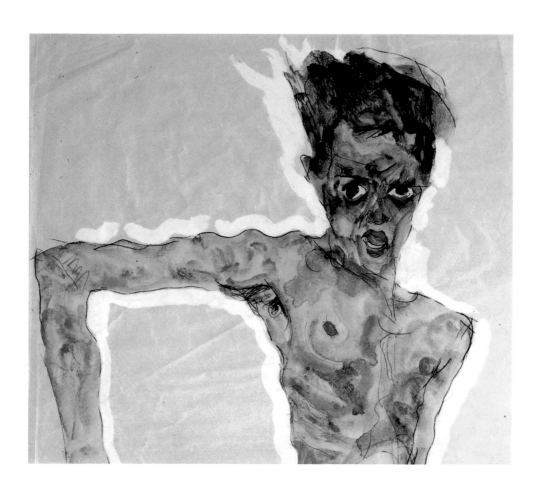

Self-Portrait, 1911 (detail)
Pencil, watercolor, and gouache with white
heightening on paper, 20 ¼ x 13 ¾ in.
(51.4 x 35 cm). The Metropolitan Museum
of Art, New York

mirror? Not just his own body, certainly: he is clearly
trying out poses, falling into habitual distortions, alien-
ating himself from himself. It makes all the difference
in the world whether he is observing his own body as
an act of direct, emotional self-knowledge or whether
in his imagination he is slipping into someone else's
role and experiencing his own self as that of another
person.

Anton Räderscheidt has reflected on the complex
issue of an artist's ability to split his own being, and to
look at his familiar appearance with the eye of a strang-
er: "The painter has self-observation in his bones. He
is used to regarding himself as an object. And yet he,
like everyone else, is taken in by his own idea of what
he looks like. His posture is deliberate. . . . He shapes
the self that he wants to be."[4]

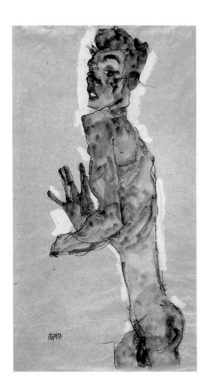

When he dramatizes himself in this way, Schiele more or less credibly assumes a specific role. His own self-awareness is no more free of historical ballast than is his choice of the pictorial medium of first-hand self-documentation. It is tempting to apply Freud's term, narcissism, to the relish with which Schiele depicts himself. But Schiele sets the ideal dialogue of self-infatuation in motion, only to wreck it at once. In Ovid, the myth of Narcissus is more than an allegory of self-love: the love itself has its motivation in the youth's own beauty and his life of contemplation. Schiele abjures all this.

Schiele's narcissistic ego is deformed. Scrawny and repellent, with its high forehead, its elongated neck, its bulky laborer's hands, its obscenely semierect member, it flouts not only any and every antique ideal but the entire concept of an "artworthy" body, as understood at the turn of the century. The back view with arms raised, joints apparently dislocated, spinal column tensed to breaking-point, red-hot ass-cheeks ringed with cold poison-green, and testicles dangling grossly between the legs, is an image of wretchedness and ugliness.

The sickly decrepitude of Schiele's early nude self-portraits reflects the social destitution of his life. His own economic misfortune is offset by the imaginative imagery of submission to—and longing for—suffering. Schiele is capable of intensifying this to the point where suffering consecrates the artist. He thus slips into the role of an antique seer, secularizing and rein-terpreting the biblical image of the prophet. Even be-fore his metaphorical adoption of the ancient pagan or biblical persona of a man outside society—as reflected by the sudden and massive change that overtook his work in 1912—Schiele's nude self-portraiture had al-ready espoused the image of the self-sacrificing Man of Sorrows: the motif of the surrogate, who takes the suffering of others upon himself.

Self-Portrait, 1911. Gouache, watercolor, and pencil with white heightening on paper, 20 ⅞ x 11 ⅜ in. (53 x 29 cm). Leopold Museum, Privatstiftung, Vienna

The Body Stigmatized

Just how uncommon it was to depict oneself naked is revealed by the fact that before 1910 only one precedent existed in the whole of Austrian art. This was Richard Gerstl's *Self-Portrait, Naked.*[5] Schiele would not have known this work, painted in 1908 but not exhibited until twenty-five years later, although he was certainly familiar with the most celebrated nude self-portrait of all, a work legitimized and consecrated by art history: Albrecht Dürer's drawing of 1506, which was preserved in Weimar and widely known through early publications. News of the scandal that had greeted Paula Modersohn-Becker's nude self-portraits of 1906 had also reached Vienna; but Dürer's work in particular must have provided an initial stimulus and a warrant for the depiction of his own nakedness—all the more so since Dürer also supplied the most important precedent for Schiele's self-image as a Christlike martyr.

Unlike his Renaissance forerunner, however, Schiele, at first, largely eliminated the motif of autohagiography —along with the intact beauty of the body, as maintained in Gerstl's Symbolistic *Self-Portrait, Seminude, against Blue Background*, of 1901 (illus. p. 56). This self-portrait by Gerstl not only refers to Dürer's drawing but adapts two of the iconographic traditions associated with Christ. Both the isolation that symbolizes the sense of exposure and of being at the mercy of an unknown power, and the passivity of the frontal stance with arms hanging loose, relate to devotional paintings of the Man of Sorrows, and to *Ecce Homo* images divorced from their narrative context. This imagery of suffering is synthesized with the iconography of the Resurrection: the pellucid appearance of the body, surrounded by an aura that stands out against the deep blue night of the ground, transports Gerstl far beyond the earthly sphere.

Schiele's iconography of the mangled body is the total antithesis of Gerstl's self-interpretation. Like his self-portraits, Schiele's "anonymous" male nudes—the mime artist Erwin Osen modeled for some, the artist himself for others—almost invariably show the body mutilated and the face distorted by a grimace. Instead of a natural expression, he depicts the culture of the mask; instead of the "presentable" face, the startling contortion.

Richard Gerstl, *Self-Portrait, Naked*, 1908. Oil on canvas, 55 ½ x 43 in. (141 x 109 cm). Leopold Museum, Privatstiftung, Vienna

Albrecht Dürer, *Self-Portrait*, ca. 1506 Graphische Sammlung, Weimar

Opposite:
Standing Male Nude, 1910. Black crayon, watercolor, and gouache on paper, 17 ½ x 11 ⅞ in. (44.5 x 30.2 cm). Private collection

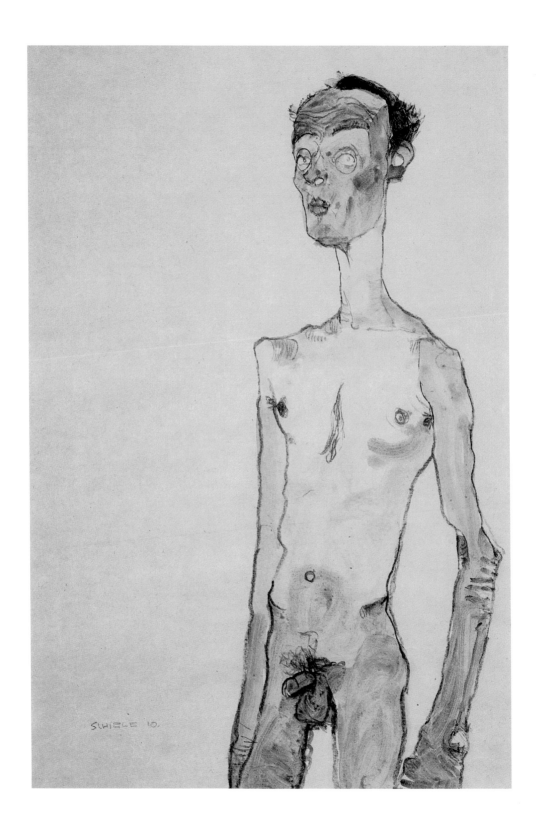

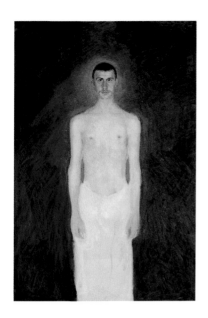

Richard Gerstl, *Self-Portrait, Seminude,*
against Blue Background, 1901. Oil on
canvas, 63 x 43 ¼ in. (160 x 110 cm).
Leopold Museum, Privatstiftung, Vienna

Schiele was no endomorph: he was an ectomorph, a leptosome. The sickly, emaciated bodies of his nudes cannot, however, be explained by his own appearance as model. Schiele is not presenting disease as disease, for its own sake; he uses it as a means to an end, to characterize the artist's psyche. Neither the grimaces nor the dislocated limbs will bear a purely objective interpretation. He is not a naturalistic artist who goes looking for models in a sanatorium. The wretchedness of Schiele's nude self-portraits symbolizes the suffering of the artist. This is why Schiele's paintings—utterly different though they are from any contemporaneous church or devotional painting—retain a religious dimension. The abject and hideous artist has his precedent in the *deformitas Christi*, the deformity of the tortured Christ, nailed to the Cross. Schiele's self-portraits of 1910 and 1911 should be read as a contribution to the art of humility, *ars humilis*.

Behind these works lies the idealization of suffering in the Romantic cult of genius, as updated in the last years of the nineteenth century through the writing of Friedrich Nietzsche and through the posthumous response to Arthur Schopenhauer. Søren Kierkegaard had already interpreted *Sturm und Drang* as a disease:

> What is a poet? An unhappy man who hides deep anguish
> in his heart, but whose lips are so formed that when a sigh
> or cry passes through them, it sounds like lovely music.
> His fate is like the fate of those unfortunates who were
> slowly tortured by a gentle fire in Phalaris's bull; their
> cries could not reach the tyrant's ears to cause him dismay;
> to him they sounded like sweet music. And people flock
> around the poet and say "Sing again soon"—which means,
> "May new sufferings torment your soul . . . "[6]

It was Schopenhauer who, once and for all, equated the madness of divine enthusiasm with insanity. The turn of the century saw the apogee of the Artist-as-Martyr legend, in which the relationship between suffering and greatness draws so close that the pose of suffering may in itself constitute a claim to the higher grades of artistic initiation.

In the nineteenth century, suffering and torment, disease and insanity, despair and moral degeneracy, became the constant companions of genius. In literature and—as the examples of Schiele and Kokoschka show—in the visual arts, the myth of the sick artist

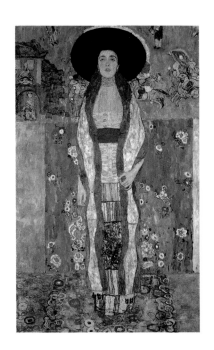

ultimately led to a stylized self-presentation as a classic case of pulmonary tuberculosis. Consumption was the stigma of the Elect, a sign of superior sensibility. In the wake of Keats and Chopin, it was a popular notion to die of consumption: Thomas Mann's Hans Castorp is a figure who undergoes a process of spiritual refinement as a result of the disease. Visually, this tradition took prototypical shape in the anemic figures depicted by the Pre-Raphaelite artists Dante Gabriel Rossetti, Ford Madox Brown, and William Holman Hunt, and later in those of Jan Toorop, Ferdinand Hodler, and Gustav Klimt. But the physically decrepit figures of Schiele add a completely new interpretative pattern: that of the ugliness and obscenity that brand the artist as a deviant from the norm.

In his essay on Schiele, published in 1911, Albert Paris Gütersloh emphasized the nightmarish, symbolic aspects of his friend's art. He painted, said Gütersloh, "those horrendous visitants who break in upon the artist's midnight soul, just . . . as they are when they enter, and not as they are when, paling under our sustained and habitual gaze, they take their leave. . . . Even the morbid, the vicious, the lewd, in a figure or a line or a gesture has not only a double meaning but a submerged meaning: it is a cipher and a stenogram . . . [Schiele] conveys . . . a meaning that goes far beyond what is supposed."[7]

Gustav Klimt, *Portrait of Adele Bloch-Bauer II*, 1912. Oil on canvas, 74 ³/₄ x 47 ¹/₄ in. (190 x 120 cm). Belvedere, Österreichische Galerie, Vienna

The Hagiography of the "Accursed Artist"

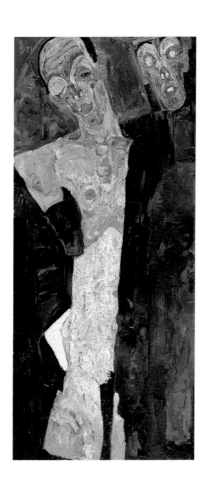

Prophets (Double Self-Portrait), 1911
Oil on canvas, 43 ⅜ x 19 ¼ in.
(110.3 x 50.3 cm). Staatsgalerie, Stuttgart

It is no accident that the image of the sick artist bears an affinity to death. The harsh outlines and festering color of *The Self-Seers II* convey not only the curse of solitude and sickness but also death, which hangs over Schiele both as a constant threat and as an emblem of his own violation of artistic boundaries. Words that appear, in Schiele's prose poems of 1910-11, to be the product of literary inspiration—"All is living dead"—become steeped, from 1914 onward, in the horrific reality of war: "We live in the most violent age that the world has ever known. We have accustomed ourselves to every privation. Hundreds of thousands of human beings miserably perish. Everyone must endure his fate, living or dying. We have become hard and without fear. What existed before 1914 belongs to another world."[8]

In *The Self-Seers II*, the disembodied, translucent, dead artist embraces the living man from behind. The artist is his own shadow; the sinister motif of the double, the *Doppelgänger*, replaces the traditional iconography of the Painter and Death, as enshrined in Arnold Böcklin's *Self-Portrait with Death Playing His Fiddle* (illus. p. 60). Schiele also appears twice in the painting *Transfiguration* (illus. p. 63), its content derived from medieval depictions of the Death of the Virgin, in which Christ receives his mother's soul while the Apostles mourn beside her lifeless corpse. Schiele sinks to the ground, his skin tones still warm. In mirror-symmetry, his bloodless figure floats aloft: fall and ascent are repesented as the contraries between which, psychosomatically, the moment of dying takes place.

Again, in *Prophets*, the double self-portrait now in Stuttgart, the artist conducts a disturbing dialogue with his other self. Schiele's self-identification with a prophet has nothing to do with precognition: it stems from his status as an outsider and a man despised. In Isaiah 53.2-4, the Suffering Servant of the Lord is described as follows: "He hath no form or comeliness; and when we shall see him, there is no beauty that we should desire him. He is despised and rejected of men; a man of sorrows and acquainted with grief: and we hid as it were our faces from him. . . ."

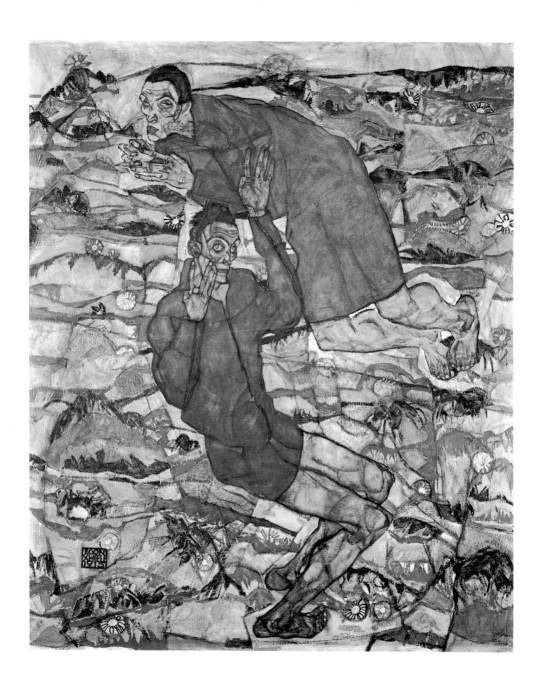

Transfiguration (The Blind II), 1915, Oil on
canvas, 78 ¾ x 67 ¾ in. (200 x 172 cm).
Leopold Museum, Privatstiftung, Vienna

The Culture of Grimacing

In a grimacing self-portrait by Schiele, as we have already pointed out, there is more culture than nature: more that is mediated by civilization than is directly felt. The grotesquerie of Schiele's self-portraits and portraits, in which he does not shrink from turning even a pretty young girl like his sister Gerti into a hideous freak, marks a turning-point in the evolution of the complex relationship between image and viewer. The gaze that looks out from a picture creates a conspiratorial understanding between the pictorial world and the beholder; but the Utopian ideal of achieved communication that is evoked by eye-contact is shattered by a grimace. Farcical truculence kills the closeness implicit in the construction of the gaze. The magnetism of the subject's gaze, which reaches out of the picture towards us, and the visual snub administered by his facial expression, are a pair of irreconcilable allies.

Here Schiele is concealing himself behind a corporeal or facial facade. The grimace is a mask, which screens out the physiognomy that has become inseparably interwoven with character and personality. The adult warning that the child who pulls faces might get "stuck that way" is intended to forestall the danger to society that self-masking constitutes. Even more than the painted picture, the portrait photograph, which depicts *only* a mask, shows how much the mask conceals the person. A rogue may lurk behind an assumed grimace; or an angel may adopt one as a disguise. A grimace affords no access to character—aside from the fact that, by definition, the well-brought-up middle-class person does not pull faces. Schiele's grimaces swamp his physiognomy; and it is this, according to Lavater's theory, that is supposed to correspond to the psyche: "Every often-repeated movement, every frequent position or alteration of the face, ultimately makes a lasting impression on the soft portions of a countenance."[11] The motions of the psyche imprint themselves as changes of mood on the soft parts of facial anatomy, and make the face in repose into a legible epitome of the Book of Life; momentary symptoms, on the other hand, are the province of pathognomy, the study of the outward signs of the passions.

Grimacing blocks all attempts to interpret the nature of a human individual through physiognomy. It was an error, all along, to refer to the grimaces recorded by

Franz Xaver Messerschmidt, *Characterhead,* ca. 1775-80

Malicious Glee. From Albert Borée, *Physiognomische Studie* (Stuttgart, 1899)

Opposite:
Grimacing Man (Self-Portrait), 1910
Charcoal, watercolor, and gouache on paper, 17 ³⁄₈ x 11 in. (44 x 27.8 cm).
Leopold Museum, Privatstiftung, Vienna

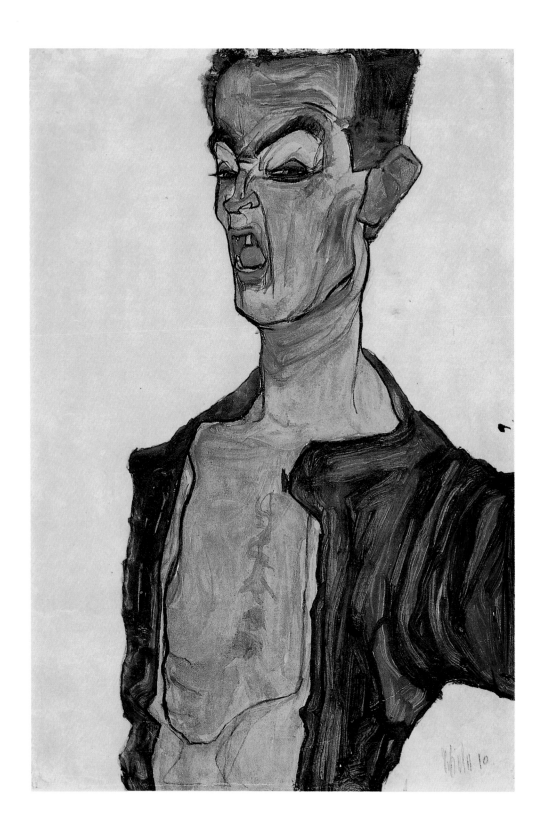

error, all along, to refer to the grimaces recorded by the sculptor Franz Xaver Messerschmidt as "character heads": they are action studies of facial expression. Similarly, Schiele's language of facial expression will bear no interpretation in terms of character. In Schiele's double self-portraits, the grimace detaches itself like a mask from the face to which it belongs: *The Self-Seers II* (illus. p. 59) is a frozen materialization of an alien, unearthly world. In *Prophets* (illus. p. 58), as in the many other paintings and drawings in which Schiele duplicates his ego, the grimace takes on the external form of a hallucination.

The idea of this pictorial equivalent of schizophrenia may have sprung directly from the debate aroused by the naming and description of the sickness by Eduard Bleuler in Vienna in 1911. As described by Bleuler, schizophrenia is a disorder of self-awareness. In it, the borderline between the ego and the outside world is abolished; parts of the body, or feelings, no longer seem to be one's own; and facial expressions and body language therefore fail to match behavior. The salient symptoms of a schizophrenic personality, as defined at that time, were firstly hallucinations and secondly a habit of pulling weird faces. The authors of psychoanalytically oriented studies, who have sought to detect psychic disturbances in Schiele, have failed to recognize the purely artistic attraction of these well-publicized symptoms of mental illness. The analytically trained art historian mistakes something that was really only a quotable attribute for the genuine article.

Georges Luys, *Expressions*, 1887

Opposite:
Double Self-Portrait, 1910, Pencil on paper, 22 x 14 ¼ in. (55.9 x 36.2 cm). Private collection

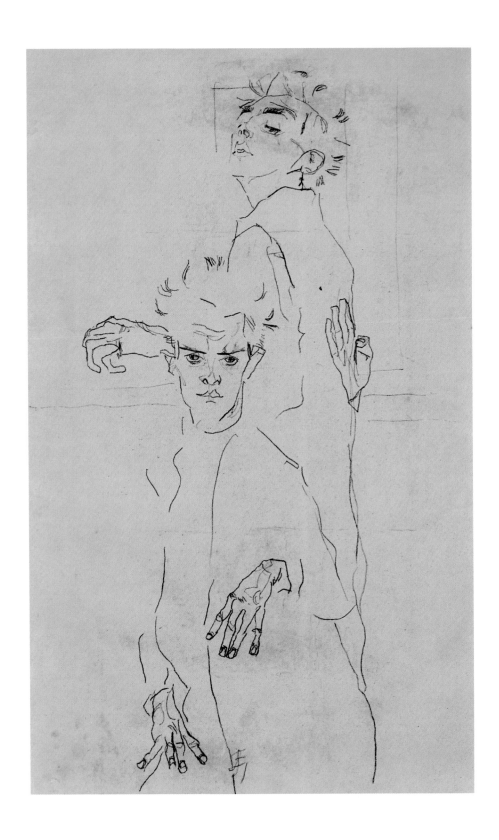

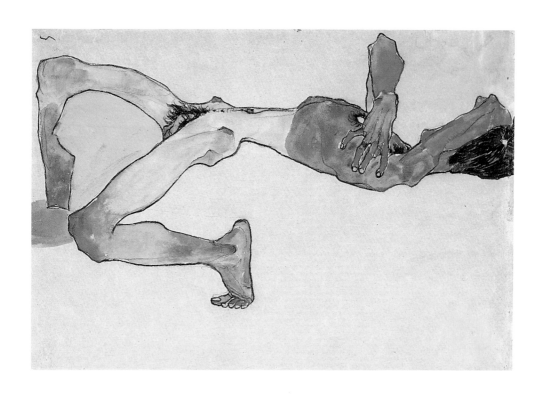

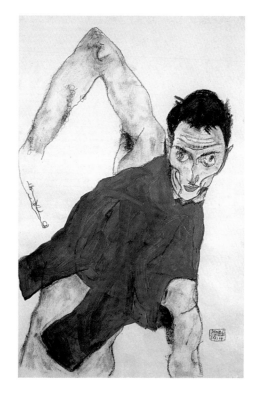

From Art to Pathology

Schiele's figure paintings and drawings live by their body language. This statement has been repeated so often that we barely notice the inadequacy of the phrase "body language" as a description of Schiele's expressive repertoire, both gestural and facial.[12] The term "language" implies comprehensibility: in language, what is said has the same meaning for the speaker as for the hearer. The same ought to apply, *mutatis mutandis*, to nonverbal communication through body language: it becomes incomprehensible when the grammatical rules are contravened beyond a certain point. For instance, manuals of etiquette provide us with a number of definitive symbolic gestures. Who would not understand the ritual gesture of prayer, or the standardized greeting, or the gestural expression of grief or triumph? We understand the meaning of the head buried in the hands: grief, when head and torso are bowed; or shame, when the posture is more upright. And even if not every nonverbal action can—like a hand-wave on parting, or a nod of assent—be literally translated into words, we grasp the meanings of many gestures because they recognizably symbolize both specific feelings and the individual's general state of excitement or arousal.

By contrast, any attempt to compile a dictionary of Schiele's gestural repertoire would soon founder not only on the arbitrariness of the gestures but also on their inconsistency: the way in which the facial expression is out of kilter with the position of the hands. In Schiele, arms expansively outstretched often coexist with a blasé facial expression; conversely, a facial contortion may well appear without the expected expressive gestures of limbs and body. Although Schiele's figures are formally seamless unities, bound into one by the outline, their innate heterogeneity disrupts the habitually expected congruence between an individual's personality and the emotional aspects of his gestures and facial expressions.

Are then Schiele's expressive gestures and grimaces expressive but meaningless? If Schiele's gestures are so blatantly *not* based on observation, what are they based on?

In terms of art history and style, the ancestry of Schiele's expressive repertoire has been adequately reconstructed. Its stylistic and typological antecedents

Hysteric-Epileptic Fit, photographic study by Paul Régnard, 1878

Opposite:
Reclining Male Nude with Yellow Pillow, 1910 Black crayon, watercolor, and gouache on paper, 12 ¼ x 17 ⅞ in. (31.1 x 45.4 cm). Private collection

Self-Portrait in Jerkin with Right Elbow Raised, 1914. Black crayon, watercolor, and gouache on paper, 18 ¾ x 12 ¼ in. (47.6 x 31.1 cm). Private collection

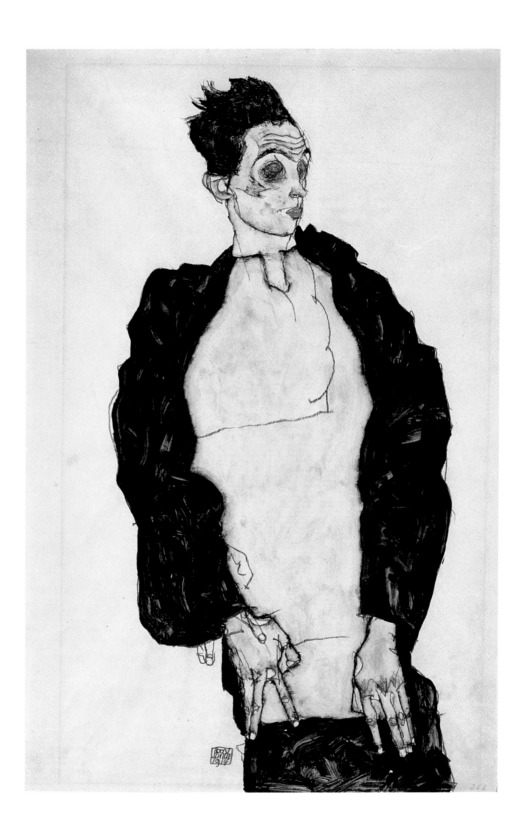

70

range from the elongated, angularly outlined figures of the geometrical linear style of Mycenaean art, and the blockiness of Egyptian sculpture, by way of Georges Minne's figures of boys and the early drawings and prints of Kokoschka, to the ideal, weightless figures of Klimt. However, Schiele's boyish, even emaciated figure type is too repellently deformed to conform to the androgynous aesthetic of the Vienna Secession. Understandably, and inevitably, when Schiele abolished the accepted limits on what could be incorporated into art, he met with incomprehension and hostility. By extending art's rightful concerns into uncharted realms of sexuality and of ugliness, he was expressly opening the doors to the pathological. This is clear from the contemporary press reviews, both favorable and unfavorable: "Schiele lives in a somber world with his horrendously distorted figures, all filled with fear, dread, terror, and despair. His women are most often utterly ghastly in their abjectness. But in one sense he is a moralist: he has never painted sin as a smiling, alluring vision of beauty. . . . "[13]

This self-conferred freedom to de-aestheticize the aesthetic was not confined to self-portraiture; but it was here that the repellent and the ugly seemed best to fit the image of the artist as a sick outsider. It was also in the self-portrait, and more generally in the depiction of the artist, that aesthetic and social norms seemed open to violation at an earlier date than in other genres. Towards the end of the nineteenth century, it became more and more common to construct the biography of the artist as a clinical case-study in modern martyrdom. In life stories from Friedrich Hölderlin to Vincent van Gogh, the myth of genius took a pathological turn. The artist's supreme creativity was presented as the fruit of his warped nature. It became increasingly fashionable and habitual for artists to attract attention by displays of eccentric behavior, as did Schiele, who was otherwise described as a quiet, retiring individual, when he clashed with the Sunday-afternoon promenaders of Krumau.

Again, Schiele arrogated special privileges to himself in dealing with his financial problems; and he expected to be able to accept or reject prospective buyers of his works according to his personal judgment of their desirability. In a sketchbook he noted: "At the very least the artist ought not to have to worry about getting the money owed to him every month . . . if the artist

Self-Portrait in Lavender Shirt and Dark Suit, Standing, 1914. Pencil, watercolor, and gouache on paper, 19 x 12 ⅝ in. (48.4 x 32.2 cm). Graphische Sammlung Albertina, Vienna

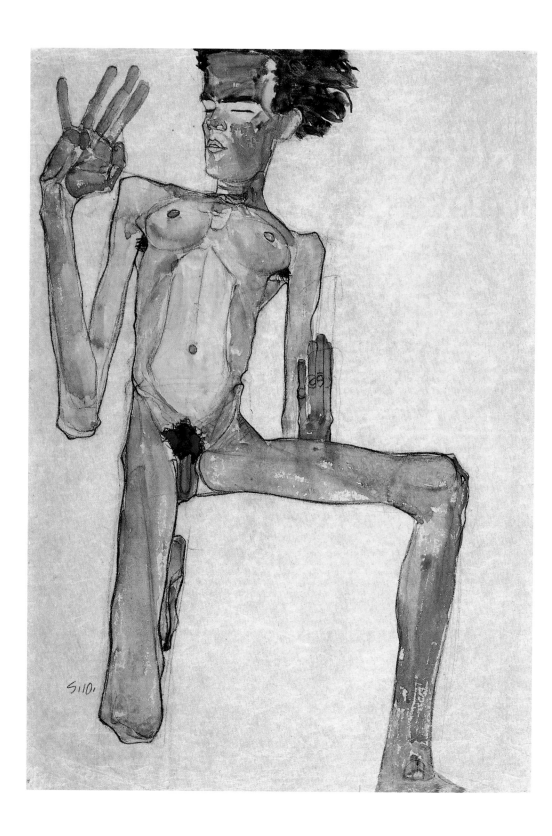

invites someone to come and be drawn, as I did Rosenbaum. So why doesn't he come? Who does he think he is? I am extremely sensitive, and all these people have no idea how to behave to an artist."[14]

One important source of this aesthetic of the artist's role was the life of Van Gogh, or rather the literary presentation of that life. The artist's psychopathology was regarded as the inevitable concomitant of his genius; his mental illness and his neurosis, and his physical decline, were the basic ingredients of the genius-and-madness myth, as philosophically formulated by Schopenhauer. The paroxysms in Schiele's self-portraits enact in effigy, through physical self-humiliation, the conflict between the artist and his uncomprehending world.[15]

Seated Male Nude with Legs Spread, Back View, 1910. Charcoal and watercolor on paper, 17 ¾ x 12 ⅝ in. (45 x 32 cm). Private collection

Opposite:
Kneeling Male Nude with Raised Hands (Self-Portrait), 1910. Black crayon and watercolor on paper, 24 ⅝ x 17 ¾ in. (62.5 x 45 cm). Leopold Museum, Privatstiftung, Vienna

The Iconography of Mangled Flesh

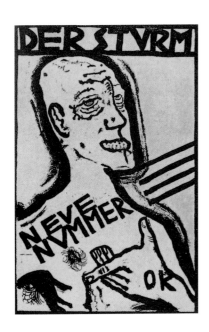

Oskar Kokoschka, poster for the periodical
Der Sturm, 1910

The iconography of mangled flesh is an aesthetic illusion. It does not stem from direct experience of life but from a number of different Western traditions of imagery. The expression of the sufferer derives not so much from first-hand experience, or from empathy with an abused subject, as from other, preexisting images, whether artistic or scientific (this last being a distinction that was not rigidly sustainable in the nineteenth century).

What we now see as traces of bodily symptoms of suffering in fact comprise the imagery and gestures of an ossified, conventional iconography of the Passion of Christ. Just as the self-portrait icon derives from the cult of *artifex divinus*, the divine artist, so the artist's pride in belonging to the tribe of "accursed artists" or *artistes maudits* springs from his defiant conviction that, unappreciated though he may be, he is at least one of the great unappreciated. This religious aspect of the theme of self tallies with the sacralization of art; just as, conversely, the artist's self-stigmatization as a lunatic and an outcast corresponds to the pathologization of art. In a kind of self-fulfilling prophecy, the artist presents himself in the subjective guise offered to him by the age in which he lives: that of a deviant from the norm.

Art critics adopted disease and dirt as their staple metaphors of condemnation. Kokoschka's works were accused by Kuzmany of a "propensity for the cruel and the contorted" (1908), by Weixlgärtner of "pathological sexuality" (1910), and by Strzygowsky of "syphilis and paralysis" (1911). In the same vein, other reviewers wrote of a "morass of color," a "sickening pap," and "delusions of youth, pathetic and diseased."[16] At the same time, and with the selfsame reference to abnormality, others absolved Kokoschka, Schiele, Max Oppenheimer, and Anton Faistauer of any duty to reproduce nature, arguing that mere visible appearances fail to capture the invisible, true nature of the human being. Gütersloh defended Schiele's art by invoking the concept of sex, which he contrasted favorably with the "logic" and "thought" of a warped civilization that had devalued human sensibility: "Approach not with your thought and your logic, there [Schiele's pictures] where

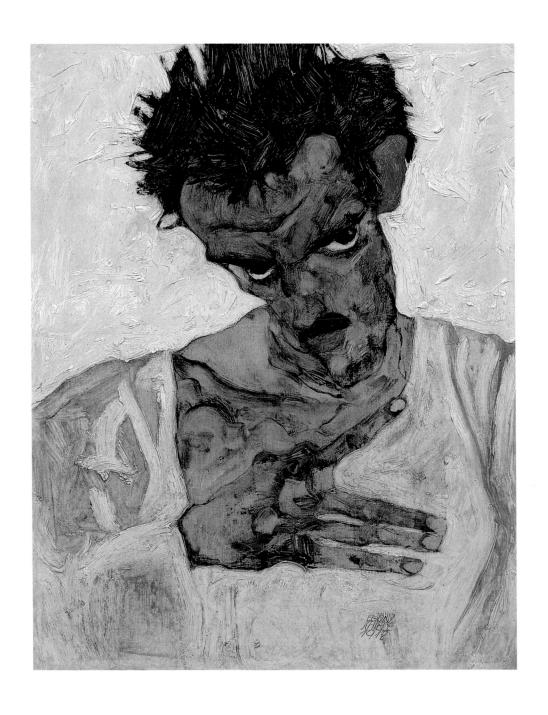

Self-Portrait with Head Lowered, 1912
Oil on panel, 16 ⅝ x 13 ¼ in. (42.2 x 33.7 cm).
Leopold Museum, Privatstiftung, Vienna

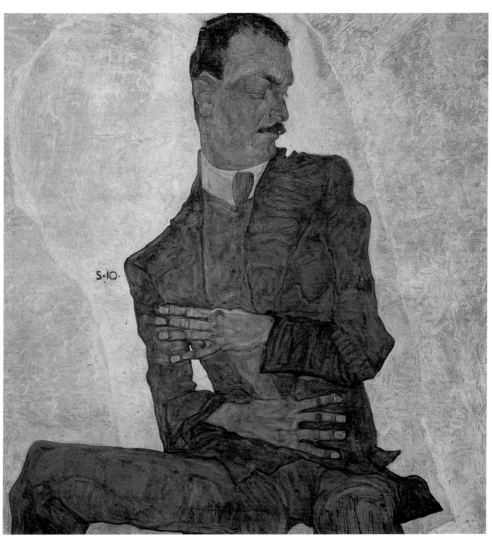

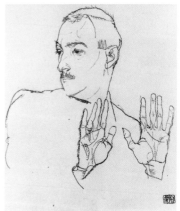

Portrait of Arthur Roessler, 1910. Oil on
canvas, 39 ¼ x 39 ¼ in. (99.6 x 99.6 cm).
Historisches Museum der Stadt Wien, Vienna

Portrait of Arthur Roessler, 1914. Pencil on
paper, 19 ⅛ x 12 ¼ in. (48.6 x 31 cm).
Historisches Museum der Stadt Wien, Vienna

you see the brain operating as a sexual organ. Have enough respect for your own sex to regard such a substitution as an insult."[17]

Gütersloh thus adduced the impulse that dwells deep in every human being as a justification for Schiele's allegedly pornographic nudes; as he saw it, only the person who stood beyond the criteria of ordinary morality—someone who could rise above the customary ideas of what constituted a depictable motif—could ever attain a proper understanding of Schiele's art.

The mutual incomprehension of artist and public was the catalyst behind the whole iconography of the artist as outcast. The child, the obsessive, the savage, proclaimed the artistic virtues of the future: naivety, spontaneity, and freedom. When Kokoschka dramatized himself as a shaven-headed, criminal outsider, he was drawing the logical conclusion from the general tenor of the criticisms. The literary prototypes of these masks of the *artiste maudit* were Baudelaire and Arthur Rimbaud: the latter was much prized by Schiele, whose own far from extensive library included a copy of a German translation of Rimbaud's poems, published in 1907.

The Christian imagery of artistic self-interpretation ranges from the artist as Demiurge to the *artiste maudit*, plagued by existential doubts. In the Classical Modernism of Western Europe, the use of such identification figures as the Monk, the Hermit, the Prophet, the Seer, the Preacher, the Voice Crying in the Wilderness or the Martyr was abandoned as "literary"; but in Vienna, Expressionists such as Schiele and Kokoschka kept Symbolism alive.

Photos from *Leçons cliniques sur l'hysterie et l'hypnotisme* (Paris, 1891)

Paul Régnard, a patient in the Salpêtrière hospital, 1878

The Decomposition of the Elements

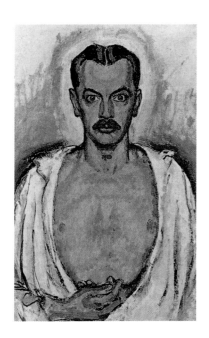

Behind all of these images of the "misunderstood artist" lies the idea of solitude, as a perverted surrogate for the inner life. This stems from the abrupt switch from an extreme of feudal and ecclesiastical dependency to the opposite extreme of social isolation. In the book *Philosophie des Geldes* (The Philosophy of Money), published at the turn of the century, Georg Simmel analyzed the conflict between individual and society:

> The individual craves to be a self-contained whole, a formation with a center of its own, whence all the elements of its essence and of its activity derive a unified, interrelated meaning. But if the supraindividual whole is to be a rounded whole, it cannot permit any of its parts to be a rounded whole in its own right. . . . The totality of the whole is constantly at war with the totality of the individual.[18]

Two points should be noted in Simmel's formulation: first, the definition of the individual and of his existence in the world in terms of isolation; and second, the notion—still steeped in the nineteenth-century conception of personality—of the compact homogeneity of the individual, his wholeness, with a center of his own from which everything comes and to which, both in essence and in action, everything relates.

If there is one thing that distinguishes Schiele's expressive use of the body from the Secessionist ideal of Hodler and Klimt, it is the loss of this center: the center that defines all the limbs. The extremities of Schiele's figures record the disintegration of the sense of somatic wholeness. The mobility of their limbs does not derive from any psycho-physical center. Balanced though Schiele's compositions are in pictorial terms— and in this respect the sureness of his hand is unrivaled —the figures themselves have no core. The points of fracture, the angularities of their crooked members, show each part to be independent of the others. The formal prop of the hermetically closed pictorial composition emphasizes rather than conceals the incompatibility of its components. Schiele's fractured figure type makes visible the conflict, archetypal of its period, between the whole and its parts.

Koloman (Kolo) Moser, *Self-Portrait*, ca. 1916
Oil on canvas. Belvedere, Österreichische
Galerie, Vienna

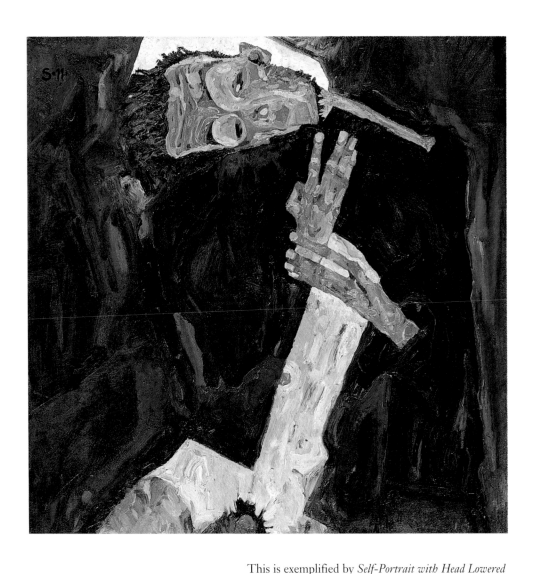

The Poet (Self-Portrait), 1911. Oil on canvas,
31 ½ x 31 ⅜ in. (80.1 x 79.7 cm).
Leopold Museum, Privatstiftung, Vienna

This is exemplified by *Self-Portrait with Head Lowered* (illus. p. 75), a study for *The Hermits*. In formal terms, the position of Schiele's hand, with the thumb tucked in and a V-shape between the first two fingers, finds its justification in the balancing reversed V of the space between shoulder and head. Such elements relate to each other formally, on the picture plane and invest each other with formal and aesthetic meaning, although in real space the advancing bowed head, the receding shoulder muscle, and the hand outspread in front of the chest belong to entirely different planes. But in terms of content they have no intercommunication whatever. Hence Reininghaus's frustration when he saw *The Hermits*.

Oskar Kokoschka, *Portrait of Auguste Forel*, 1910. Oil on canvas, 27 ½ x 22 ¾ in. (70 x 58 cm). Städtische Kunsthalle, Mannheim

Let us compare this with the *Self-Portrait* of 1916 by Koloman Moser (illus. p. 78).[19] As in Schiele's self-interpretations, Moser employs a halo as an icono-graphic sign of the artist's hypertrophied ego. But in complete contrast to Schiele, content and form—composition, posture, gesture, and facial expression—all relate to each other! One element gives rise to the next; the hieratic gaze is matched by the strict symmetry of the composition; the form of the nimbus is echoed by the open shirt. The formal center coincides with the central focus of the content, to which the hand points. By contrast, Kokoschka had been denounced for impermissible infidelity to his subject in his *Portrait of Auguste Forel*;[20] but, as proof of his visionary powers, there is an enduring legend that the much-criticized hand gesture shown in the portrait was a premonition of the aged scientist's uncoordinated movements when, two years after the sitting, he suffered a stroke.

Simmel's account of the rift between individual and society leads to another conclusion. The trauma of total isolation, by which the artist is threatened, results from his loss of undistorted communication with the world. The noncommunicative gestural language of Kokoschka's Forel portrait, or of Schiele's portraits of himself and others, such as the 1910 portrait of Arthur Roessler (see illus. p. 76), are vivid symbolic figures of social alienation. The more expressive the gestural language, the clearer this is. The more we strive to understand the body grimace—and the more it seems staged for and addressed to us, though we have no key to it in our own experience of life—the more horrific it becomes. The trance-like state of many of Schiele's portrait sitters asserts their inaccessible remoteness of mind and spirit. In Schiele's portrait of Roessler, the sitter wears the relaxed facial expression of a peaceful sleeper. At the same time, he twists his head violently onto his hunched left shoulder, while the right shoulder sinks down deep and long. With the trunk and head in such psychic disharmony, the big hands are equally out of keeping. Angled and tense, they are displayed by this representative of the literary profession with calculated ostentation—but without their thumbs they cannot grasp and cannot write.

The Poet (illus. p. 79) and *Self-Portrait with Black Clay Vase and Spread Fingers* of 1911 obey the same abstract design principle, with its disregard of the psychological and motor coordination of the limbs. Rudolf Leopold

Self-Portrait with Black Clay Vase and Spread Fingers, 1911. Oil on panel, 10 ⅞ x 13 ⅜ in. (27.5 x 34 cm). Historisches Museum der Stadt Wien, Vienna

has made many analyses of the structural frameworks of Schiele's paintings and drawings, in which every form is the implicit consequence of another form, and every *Gestalt* has its counterpart. This should not cause us to lose sight of the fact that in every case Schiele unites the irreconcilable. On the level of the unconscious, the same dislocation even finds its way into the title of *Self-Portrait with Black Clay Vase and Spread Fingers:* the conjunction "and" seems involuntarily comic, somehow surreal. The "and" suggests an unsuccessful attempt to connect the vase with the hand, rather than any affinity between these incompatibles. What imposes (solely compositional) unity on the contradictory content? What is the source of the formal principle of seeing disparate objects conjoined? What is the source of the disparity itself?

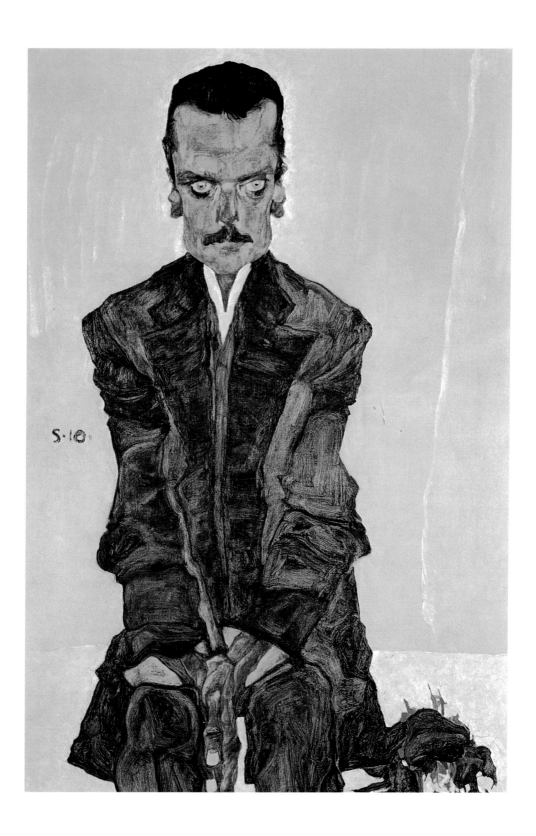

The Rhetoric of Bodies Possessed

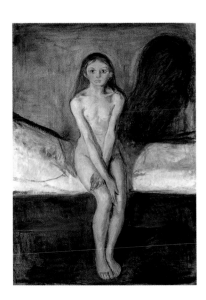

As the distractions in these works are certainly not standardized, symbolic actions, can they be authentic gestures or are they borrowed? Perhaps the whole opposition between genuine, unmediated expressive forms and culturally preformed bodily repertoire is an artificial one—by analogy with Aby Warburg's insight that the new Renaissance sense of the language of the body, and of its ability to express extreme feelings, stemmed from contact with the antique figures of maenads dancing in an ecstatic frenzy. Perhaps, too, in order to counter the inflation and consequent devaluation of all known forms of expressive body language, Schiele in turn sought and found a still-unhackneyed repertoire of "emotive formulas" (Warburg's *Pathosformeln*). Not that this repertoire came unbidden. From the outset, it was closely related to the new self-image of the artist: to his isolation in particular, and to the alienation of the individual from society in general.

Superficially, the pose adopted by the publisher Eduard Kosmack in Schiele's 1910 portrait bears a close affinity to the celebrated pose of the naked girl in Edvard Munch's Symbolist painting *Puberty*. But what Munch expresses in the figure's crossed legs, and in the way she crosses her arms in front of her sex, is her shame at the exposure of her maturing body. The Viennese publisher is fully dressed, and his hands cover no shame; his arms are convulsively pressed to his body, and his hands clamped between his knees. Everything about him expresses duress and pressure. The concave outline is the visual equivalent of this pressure, which rests on the sitter from outside. The unnaturally wide-open eyes confirm this.

The closest analogies to this image are to be found in the photographs of hysterical patients taken for (and sensationally published by) the alienist Jean-Martin Charcot. Himself a practicing artist, Charcot was one of the first physicians to press the new technique of photography into the service of medicine; under the title "Hysteria," he gave the world some striking action stills of the drama acted out by male doctors and their female patients. His photographs of female hysterics, and other instructional photographs in the fields of medicine and ethnography, provided an important

Edvard Munch, *Puberty*, 1893-94. Oil on canvas, 59 ½ x 43 ¼ in. (151 x 110 cm). Nasjonalgalleriet, Oslo

Opposite:
Portrait of the Publisher Eduard Kosmack, 1910. Oil on canvas, 39 ⅜ x 39 ⅜ in. (100 x 100 cm). Belvedere, Österreichische Galerie, Vienna; on extended loan to the Museum moderner Kunst, Vienna

visual stimulus because they demonstrated that a human being possesses a far wider range of expressive and gestural resources than had previously been supposed. The most influential images were those in the three volumes by D. M. Bourneville and Paul Régnard, *Iconographie de la Salpêtrière*, published in Paris between 1876 and 1880. It was not that any specific pose led to artistic imitation: the sum total of these images simply exploded the traditional concept of personality.

The eighteenth-century French encyclopedist Denis Diderot once remarked, on seeing a successful likeness of himself, that it did not really represent him: he said that he had a hundred physiognomies every day, each corresponding to a new stimulus. The inventor of electrotherapy, Guillaume-Benjamin-Armand Duchenne, experimentally produced a wide variety of facial expressions in a patient by administering electrical stimuli, and photographed the results. As early as 1856-57, when the photographs were taken, Duchenne realized how his discovery could stimulate the imagination: "How easy to determine the motion of the facial muscles! Armed with rheophores, we can paint the expressive traits of the soul's motions on the human face, as Nature herself does. What a source of new observations!"[21]

The new interest in partial and isolated factors—in the face, the hands, the other parts of the body—was catered for by a variety of branches of scientific and pseudoscientific photography. Within the history of ideas, the semiotics of hysteria fitted perfectly into the pathologization of art. The signs made by the female patients had always been a Theater of Hysteria; but until they were documented by photography they were regarded as natural, somatic symptoms and not as what they really were: quotations from, and variations on, works of art. Charcot's spectacular circuses in the lecture hall of the Salpêtrière hospital were preserved for posterity by candid photography.

His most talented model was Augustine, a consummate performer whose range extended to every register of hysteria, and who also had an unrivaled command of the dramatic logic that yielded the most effective sequence of episodes. Augustine deservedly became Charcot's star patient, always invited to take the stage at the Salpêtrière whenever there was a call for the maenadic signs of Possession—the head tossed back, the catalepsy, the magnificent contortions—or

Paul Régnard, photographic study of a patient with acoustic halucination, 1878

Opposite:
Self-Portrait with Hand to Cheek, 1910
Charcoal, watercolor, and gouache on paper, 17 ½ x 12 in. (44.3 x 30.5 cm).
Graphische Sammlung Albertina, Vienna

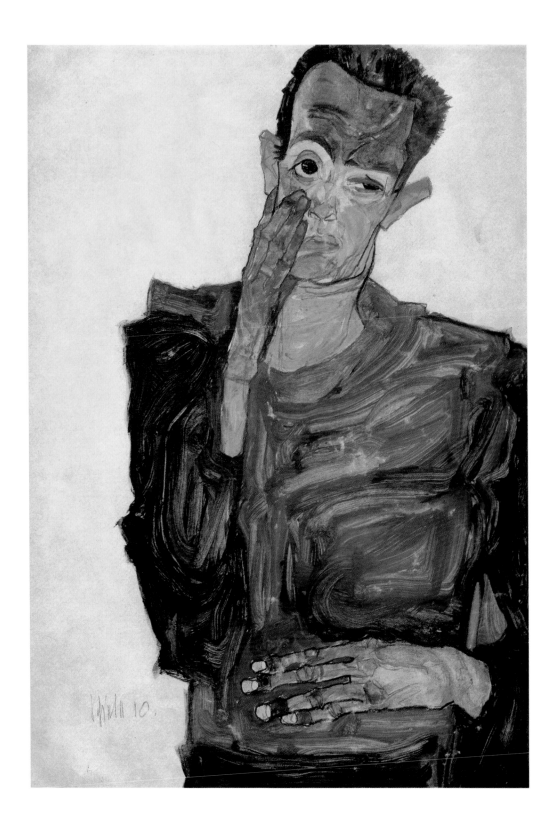

the various spastic actions of the Epileptoid Phase. She was equally good in the calmer phases, in which cataleptic arm and hand positions contrasted with a lethargic facial expression, just as in Schiele's portraits.

As early as 1890, the French psychiatrist Jules Falret saw through the imposition: "These patients are veritable actresses: their greatest pleasure is to deceive everyone with whom they come into contact. The hysterics, who exaggerate their convulsive movements, make corresponding travesties and exaggerations of their feelings, thoughts, and actions. . . . In a word, the lives of hysterics are one long falsehood."[22]

In view of the pathological source of these entirely new gestural epigrams of emotional excitement, it comes as no surprise that Schiele's facial and gestural vocabulary met with widespread incomprehension. In 1908, the writer Peter Altenberg still believed in a coherent relationship between visible outward behavior and invisible inner essence: "Every human being moves according to the degree of his or her inner culture. Show me how you walk, stand, sit, and I will tell you who and what you are. . . . Motion has hitherto been mere mechanism; it is now the outward expression of the person's innermost nature."[23]

The legibility of the hand gestures as pictorial signs is obscured by the generalized message of deviance from the norm. The hands in Schiele's works are not tools, and facial expression is seldom an indicator of natural emotions; combined, hands and faces do not relate to any pictorial narrative, however vestigial.

Taken together, the pictorial volumes that recorded convulsive pathological symptoms provided Schiele with a pattern book of new and unhackneyed gestures. His use of these pathological sources was justified by the conviction that a personality no longer embodied an immutable character, a temperament, an essential being. On the contrary, every ego was multiple, because it was composed of alarmingly contradictory elements.

It was Ernst Mach who radically subjectivized the notion of personality, dissecting it into the multiplicity of its emotions, and in this he was followed by Hermann Bahr and Hugo von Hofmannsthal. Simmel's sociological approach to personality similarly had the consequence of dividing it into discrete components, separate role images, and group affinities. Thus fragmented from all sides, the personality needed the

Photograph of a tetany patient, 1878

Self-Portrait with Head Lowered, 1912
(detail; see illus. page 75)

Egon Schiele and Anton Peschka in
Krumau, 1910

Opposite:
Gustav Klimt, *Seated Nude*, 1913. Pencil on
paper, 23 ½ x 14 ¾ in. (59.9 x 37.3 cm).
Graphische Sammlung der ETH, Zurich

Observed in a Dream, 1911. Pencil and
watercolor on paper, 18 ⅞ x 12 ⅝ in.
(48 x 32 cm). The Metropolitan Museum
of Art, New York

Reclining Woman, 1918. Charcoal on paper,
11 ⅝ x 18 ¼ in. (29.5 x 46.4 cm).
Private collection

quick-registering medium of photography to capture a
single, unique facial expression and thus supplant the
"synthetic" portrait of which Simmel spoke, with a
backward glance at Rembrandt, rather in the tone of an
in memoriam notice. Instead of a portrait that marked a
synthesis of the sum total of possibilities represented
by a human life, there was now a photograph for each
moment.

For Schiele, the one, ideal face of a human being no
longer existed. His portraits are therefore valueless to
the physiognomist, who relies on the durability of ex-
pression as a mark of character. Schiele's familiarity
with all these phenomena derived from his friendship
with the gynecologist Dr. Erwin von Graff. It was Graff
who made it possible for Schiele to visit the *Frauenklinik*
in Vienna and draw pregnant women and newborn or
stillborn infants. Hysterics were treated in the same
clinic as this disorder was deemed to be specific to wo-
men. In addition, Schiele's friend, the mime Osen, vis-
ited the State psychiatric hospital, *Am Steinhof* (Vienna
XIV), to make studies of pathological expressions.

In art, the influence of the choreography of hysteria
pushed back the frontiers of acceptable subject matter
to include mental abnormality; at the same time, the
new hysterical and convulsive iconography shatteredthe
classical canon of beauty. It was also clear evidence of
the presence of hidden (but none the less powerful)
forces within the human being. In style, even more
than in subject matter, this extension of emotional
expression made available a new aesthetic of ugliness.

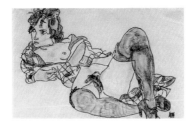

The Beauty of Ugliness

Beauty and its negation, ugliness, elude definition in terms of any specific object. The statement that any one motif —uncouth peasant, excrement, genitalia, decomposing corpses—is in itself ugly lacks the self-evidence to which it lays claim. Ugliness, nastiness, and obscenity are all undeniably a matter of degree as can be demonstrated by comparing the identical erotic poses adopted by the women in Klimt's and Schiele's drawings: in Klimt's Secessionist work, formal devices cushion the impact of raw reality, while Schiele uses color accents to draw attention to the taboo object.

There is no systematic way of classifying what has at various times been marginalized or excluded from the category of the beautiful. The aesthetics of the unaesthetic are subject to only one law, which is that in every case a canon is set up, only to be breached and followed by new forms of license, which eventually age into a new canon. The emancipation of the no-longer-quite-so-fine arts in modern times can only be conceptualized in relative terms. Karl Rosenkranz (a disciple of Georg Wilhelm Friedrich Hegel) remarked on this, in his book on the Aesthetics of Ugliness: "Beauty, like Goodness, is absolute; and Ugliness, like Evil, is relative."[24]

It is the concepts of beauty and ugliness that mark the boundaries between Jugendstil and Expressionism; a transition chronicled by the Viennese critic Ludwig Hevesi as follows:

> All liberators have resorted to ugliness as a sure specific against the curse of banal beauty: of preordained, universal prettiness. From Böcklin and Klinger to Toorop and Klimt, there runs a passionate impulse to adjust and reevaluate the concepts of beauty and ugliness. . . . We have hitherto believed that ugliness, like the other undesirables of the nether world in which we live, could be conciliated by humor. . . . But it now becomes apparent that there is another universal conciliator: style. For two generations now, the whole of Nature has been modeling for artists. She has had enough of it. A universal demand for style pervades the world. All this matter must once more be suffused with mind and spirit.[26]

All the traditional vestiges of Symbolism and Aestheticism that can be detected in Schiele's work pale

into insignificance by comparison with his total demolition of the concept of beauty, a concept that was central to the world of Klimt and his circle. As soon as form lurches rudely into ugliness, the category of moral goodness implicit in beauty also disappears. Schiele and Kokoschka, with the strident emphasis on ugliness that was their artistic counterblast to the harmony of the *Wiener Werkstätte*, violated the latter's guiding concept of "self-identity." Not only are Schiele's double self-portraits the emblems of a riven personality: every one of his self-portraits takes as its subject a different facet of the artist's ego. Every one abandons the unity of beauty and character. It is idle to seek the real Schiele. Outside and inside, surface and depth, are no longer related variables. This was one of the more important factors that lent legitimacy to the idea of the "portrait without a likeness," which—in Kokoschka's hands—so often aroused the sitter's ire.

In Schiele's early pictures of children the objective embarrassment of the models' lowly social origins is reinforced by the embarrassment of their obscene nakedness. These children have nothing in common with the child as a naive, sweet creature who appeals to the viewer's protective instincts. That child had survived, almost intact, through successive phases of stylistic change from Biedermeier to Secessionism. But Schiele's children do not play. Even more than his adults, they lack the surroundings in which to be themselves. On the white expanse of the paper, they do not *exist*; they *are exhibited*. The true obscenity lies partly in this isolating ostentation, which puts paid to any aesthetically distancing response on our part. We have to take the children as they are, sexuality included.

In his account of Schiele's drawings of children, Roessler has left us authentic contemporary evidence of the compulsive need to believe in the reality of these images. The objective content and its ugly coloring precluded aesthetic contemplation:

Three Street Urchins, 1910. Pencil on paper, 17 ½ x 12 ⅛ in. (44.6 x 30.8 cm). Graphische Sammlung Albertina, Vienna

Opposite:
Standing Nude Boy, 1910. Black crayon and watercolor with white heightening on paper, 17 ⅝ x 9 in. (44.8 x 22.9 cm). Szépmüvészeti Múzeum, Budapest

For months on end, he was occupied in drawing and painting proletarian children. He was fascinated by the havoc wrought by the sordid sufferings to which these—in themselves—innocent creatures are exposed. He wondered at the curious changes in the skin, with watery blood and polluted juices trickling sluggishly through its slack vessels; the green, light-shy eyes beneath their inflamed, reddened lids, the scrofulous finger joints, the mucus-

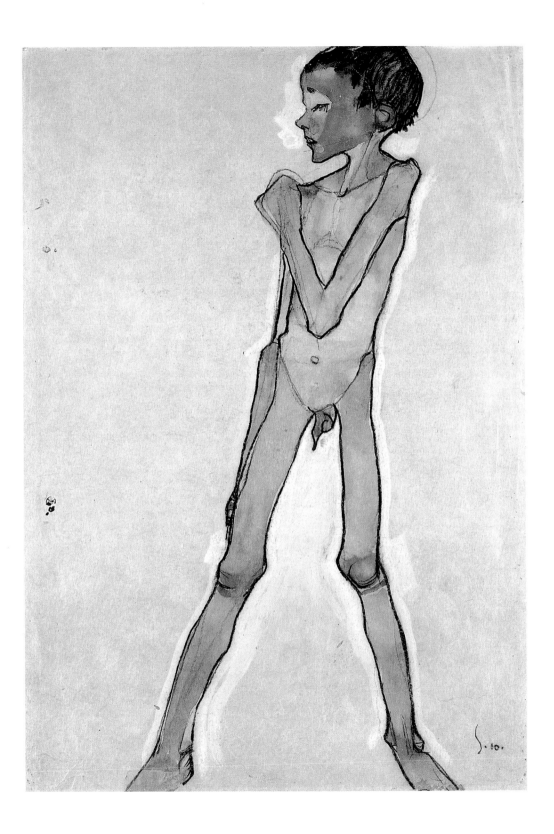

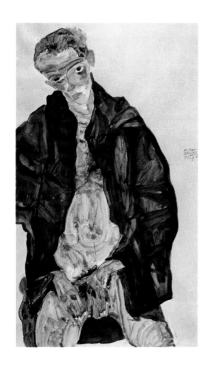

dribbling mouths—and the soul that lives within these sordid vessels.[26]

The obscene drawings of children masturbating, the shameless displays of the juvenile vulva, are difficult to describe, because their effect is an intrusion on the intimate life of the viewer. Even the most rarefied formal analysis inevitably turns into a statement of belief. The question of whether these drawings were art or pornography was as pressing for Schiele's contemporaries as it is ignored today. It was a distinction that the Romantic writer Jean Paul had tackled long before. His objection to the painting of sensual love was not a moral but a poetic one:

> There are two emotions that admit of no free, pure artistic enjoyment, because they force their way out of the painting and onto the viewer, twisting contemplation into suffering. These two are disgust and sensual love. Admittedly, in relation to the latter, people expect quite the opposite from the beholder; but first give him a handful of thin, silver hair and a sedate age of eighty.[27]

According to Jean Paul, only caricature can hold disgust in aesthetic suspense; only old age can immunize us against sexuality. With few exceptions, Schiele dispenses with the device of caricature. His nudes distinguish themselves by the fact that, within the institution of art, without humorous exaggeration or atmospheric mitigation, they call a spade a spade; they afford a direct demonstration. Schiele's realistic concerns are visible precisely in the "parts" to which the vice squad objected. The sexual becomes brute fact. By the nature of the subject, here as elsewhere, the actual threshold of embarrassment, the trigger of the sexual stimulus, is a function of period, cultural context, and individual respose.

Self-Portrait in Black Cloak, Masturbating, 1911. Pencil, watercolor, and gouache on paper, 18 7/8 x 12 5/8 in. (48 x 32.1 cm). Graphische Sammlung Albertina, Vienna

Opposite:
Nude Self-Portrait, 1910. Black crayon, watercolor, and gouache with white heightening on paper, 17 5/8 x 12 3/8 in. (44.9 x 31.3 cm). Leopold Museum, Privatstiftung, Vienna

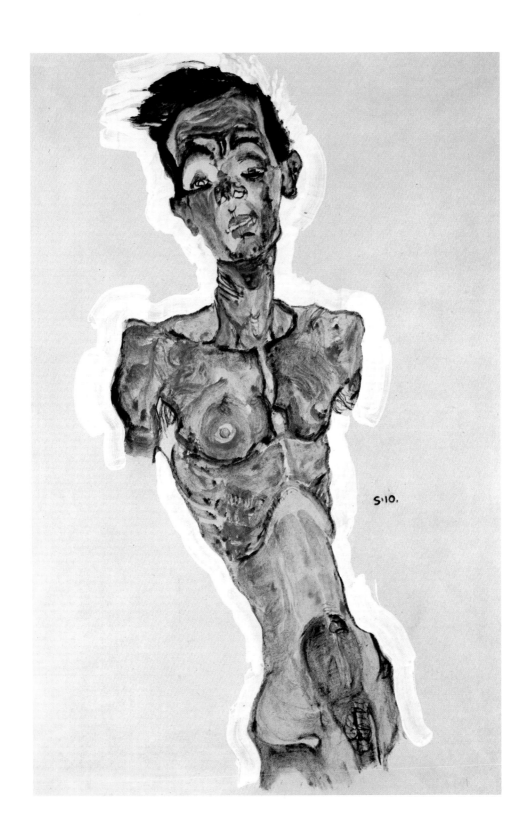

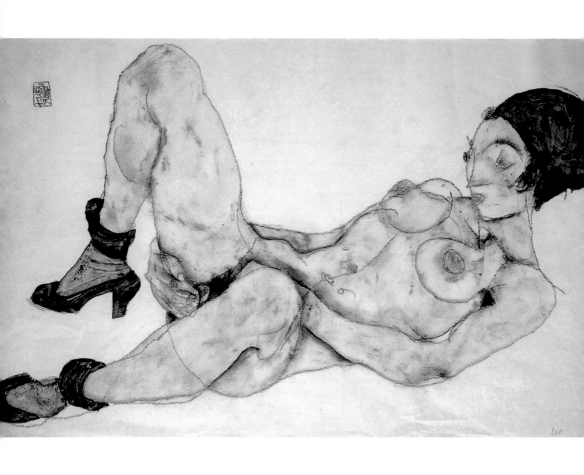

Nude with Green Turban, 1914. Pencil
and gouache on paper, 12 ⅝ x 18 ⅞ in.
(32 x 48 cm). Private collection

Shamelessness as an Aesthetic Principle

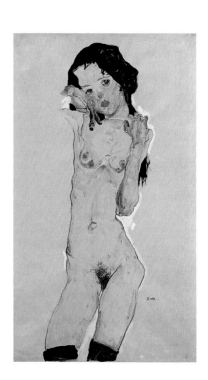

Black-Haired Nude Girl, Standing, 1910
Watercolor and pencil with white heightening
21 ³/₈ x 12 ¹/₈ in. (54.3 x 30.7 cm).
Graphische Sammlung Albertina, Wien

"And they were both naked, the man and his wife, and were not ashamed. . . . And when the woman saw that the tree was good for food, and that it was pleasant to the eyes, and a tree to be desired to make one wise, she took of the fruit thereof, and did eat, and gave also unto her husband with her; and he did eat. And the eyes of them both were opened, and they knew that they were naked; and they sewed fig leaves together, and made themselves aprons." [Genesis 2.25; 3.6-7]

Only when equipped with knowledge can the human being know and be ashamed of his or her nakedness. In a state of innocence there is no such thing as embarrassment. It was only in paradise that Adam and Eve disported themselves naked, among the animals, as if among their own kind. If Eve had rejected the Serpent's proffered apple, humanity would have known no shame and no shamelessness. There would have been no depictions of ideal modesty, and no works that derived their main attraction from transgressing a code of decency.

The Christian myth of the origin of the world tells us that human beings created culture solely as a result of shame. The covering of nakedness has become a symbolic shield against the perceived threat of sexuality; paradisal nudity becomes possible again only at the Last Judgment. Only on the last day will man appear before the Throne of God in the splendor of innocence, as God created him. Until then, nakedness remains wrong, and shame accompanies human existence on earth as a control device. In the guise of "decency" and "morality," it has been internalized, marking a firm divide between instinct and culture, turning body and psyche into irreconcilable adversaries. Many years after the Book of Genesis, Max Scheler wrote on "Shame and Modesty": "And the wider the gulf in a person between the aspirations of his spirit and the power of his life force and his senses, the greater must be his shame, if his personality is not to explode."[28]

The theme of the confrontation between nature, as represented by the sexual drive and the lack of self-restraint, and culture, as represented by civilized morality, has been a constant one; but every age has found pictorial strategies of its own to deal with the conflict.

Of these, the most influential has been that of the idyll. This genre enshrines the nonalienated coexistence of humanity and nature; it is the locus of reconciliation between nature and culture. In the fictitious imagery of the idyll, peace and tranquillity prevail. All that is vile and mean is excluded, as are those feelings associated with desire and gratification.

The seventeenth century, especially in Holland and Flanders, certainly took a skeptical view of this myth of peace. Rembrandt, in particular, repudiated the traditional iconography of the idyll by presenting erotic and sexual motifs: from the unidealized woman, by way of the libidinous shepherd, to depictions of bodily excretion and scenes of intercourse. But it was only genre painting that presided over the artistic interpretation of life in its erotic, ugly, obscene aspects. The doctrine of the hierarchy of genres (*genera dicendi*), which governed all matters of decorum (i.e.,the matching of style to subject), prescribed the comic or moralizing slant that had to be placed on objectionable subject matter. Disdained and patronized by the superior kind of art (*genus grande*), the humble kind (*genus humile*) was permitted to amuse itself with matters of no importance. But whenever the work acquired autonomy, as a "raw fact" of nature in its own right, the aesthetic and the ethically commendable—which in the work of art were always united—parted company. Caricature and pornographic drawing simply ignored the lofty demands of art.

Schiele's nudes are unsanctioned by any artistic genre; nor are their audacities tamed by any pretext of moral indignation. In Schiele's art, aesthetics disowns itself, and art disowns its tradition. Writing under the influence of Idealist aesthetics, Rosenkranz still regarded beauty and decency, or indecency and ugliness, as interrelated: "The obscene consists in the intentional violation of decency."[29] For Schiele, the aesthetic form and the sexual stimulus generated by the object are no longer contraries. It was not until the beginning of the twentieth century that the obscene became an object for art in its own right. The sexual act between a monk and a peasant woman in a cornfield, in a Rembrandt etching, is a realistic motif, and thus formally still part of stylistic history; it is the *genus humile*, and thus still part of the history of genres; it is a motif *not* intended for value-free contemplation, and thus still part of morality.

Nude Girls Reclining, 1911, Pencil and watercolor on paper, 22 ¼ x 14 ½ in. (56.5 x 36.8 cm). The Metropolitan Museum of Art, New York

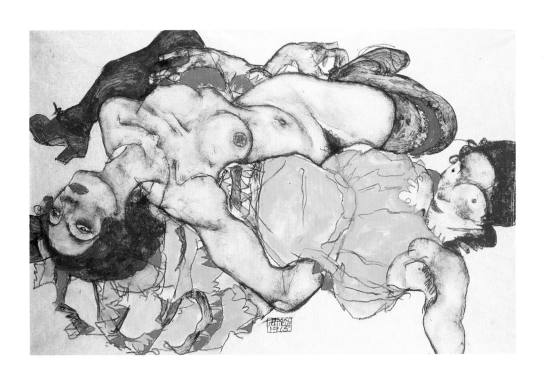

Two Girls, Lying Entwined, 1915
Pencil and gouache on paper,
12 $\frac{7}{8}$ x 19 $\frac{5}{8}$ in. (32.8 x 49.7 cm).
Graphische Sammlung Albertina, Vienna

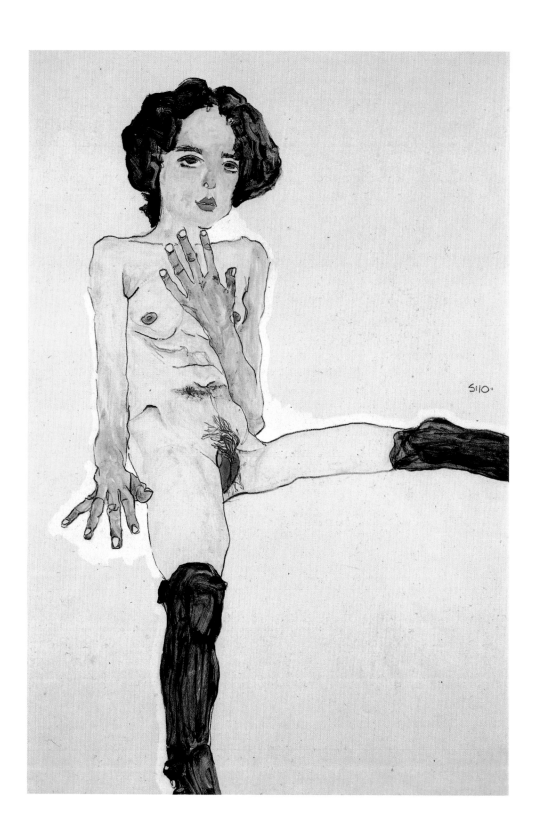

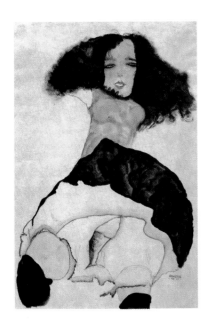

Schiele's *Nude Self-Portrait* of 1910 (illus. p. 93) and his *Seated Female Nude with Black Stockings* not only violate contemporary ideas of decency by their unvarnished directness. In formal terms, they also fail to meet the criteria of beauty—either the conventional norms of a tempered naturalism or the stylized ideal of the Klimt circle. Klimt dematerializes the substance of the body and dissolves it in a decorative play of movements; he thus deprives his female nudes of the realism that is the first prerequisite of the demolition of aesthetic detachment.

It is, of course, a commonplace of art history that Austrian Expressionism in general, and the art of Schiele in particular, exist by destroying taboos. The trouble is that this act of destruction is no longer a real experience to us in either sensual or emotional terms. Who is incensed, nowadays, by Schiele's confessional mania, or by his countless depictions of the nude? Who is still appalled by his depictions of girls shamelessly masturbating, of lesbian couples, and of men and women copulating? And yet these works owe their very existence to the taboos of their time. Whether regrettably or not, the taboos of our grandparents and great-grandparents—who were once Schiele's accomplices in his artistic violations of propriety—are as much a thing of the past as their ideas of privacy or "inner life." And this means that some of the original impact of Schiele's work has been lost. Along with the moral coercions and habitual taboos, the shamelessness manifest in Schiele's art, which was its essential aesthetic principle, has disappeared.

Girl with Black Hair, 1911
Pencil and watercolor on paper,
22 ¼ x 14 ¼ in. (56.5 x 36.2 cm).
The Museum of Modern Art, New York

Opposite:
Seated Female Nude with Black Stockings, 1910
Pencil, watercolor, and gouache with white
heightening on paper, 21 ¼ x 14 ¼ in.
(54 x 36.2 cm). Private collection

The Display
of the Repressed

In an exhibition review in the *Wiener Abendpost* of 21 March 1918, Arnim Friedemann wrote of Schiele's erotic images: "Schiele preference is to paint and draw the ultimate in vice and the ultimate in degradation; woman as an instinct-ridden herd animal, rid of all the inhibitions of morality and shame. His art—and it is art—does not smile: it grins a ghastly and distorted grin."[30] Schiele makes a point of displaying the secret, the hidden, the repressed.

In *Black-Haired Girl with Raised Skirt* the dark skirt material cascades around the girl's white underclothing, in the same way that her black hair frames her light face. The female genital area is presented—to adopt Leopold's happy formulation—like a bullseye, or like the Sacred Heart of Jesus. Schiele counters repression with ostentation: he counters the wish to forget by bringing things right out into the open. The concept of repression, introduced by Freud to describe the central defense mechanism of the psyche, soon became a central notion of psychoanalysis. Leopold's deft *aperçu*, which locates sex somewhere between lethal aggression and devotional imagery, shows just how impossible it was for rigidly Catholic Conservatism ever to prise the spiritual away from the physical, as long as the gratification of physical needs was ideologically defined as incompatible with the unfolding of spiritual and moral impulses.

In art, the danger was that the psyche might be defiled by physiology—and this could be avoided only through the use of stylization, to reduce sexual stimulation and obscenity to the tamed eroticism of mood. This was Klimt's way, but it was not Schiele's, though we should not forget that Klimt's faculty paintings, also aroused moral indignation. Karl Kraus, though no great admirer of Klimt, was moved to speak out, if not in his favour, at least against his adversaries: "One may object to the intellectual pretensions of Klimt's faculty paintings, but in the last resort it really will not do to abuse this extraordinarily able artist just because his female figures are not 'curvy,' and because they fall short of the ideal of being 'as pretty as a picture.' "[31]

To appreciate to the full the outlandish, scandalous, *verboten*, exclusive quality of Schiele's erotic drawings,

Gustav Klimt, *Medicine*, 1900-7 (destroyed)
Oil on canvas, 14 ft. x 10 ft. (430 x 300 cm).

Opposite:
Black-Haired Girl with Raised Skirt, 1911
Pencil, watercolor, and gouache on paper,
22 x 14 ⅞ in. (55.9 x 37.8 cm).
Leopold Museum, Privatstiftung, Vienna

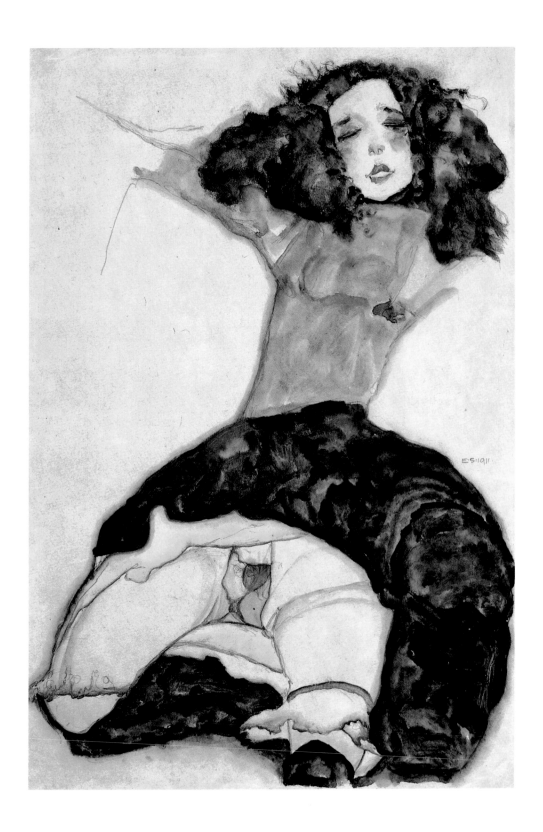

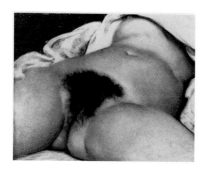

we must be aware of the extent to which the bourgeoisie, before the outbreak of World War I, suppressed their intimate life and shrouded all the manifestations of the body and of sexuality in secrecy and shame. All bodily functions were repressed by a moral imperative that was memorably summed up by Tilla Durieux: "A decent girl has a head and two hands and nothing, but nothing, else."[32]

Schiele's *Female Nude with Folded Arms*, a life study of his younger sister Gertrude intended for one of the paintings in his big 1910 series of nudes, illustrates the dialectic between the shamefaced posture—the head turned away, the arms crossed in front of the breast—and the violation of the integrity of the person, as represented by the baring of the sexual organ. In the impact of this drawing, in which the girl surges up like a column, its typological source (the fountain figures of Minne) is secondary. The formal refinement is subverted by the directness of the depiction.

Schiele's nudes mostly draw their life from the antithesis between covered and bared areas of the body. This makes them equally remote from the bourgeois repression of human sexuality and from the paradisal nakedness of naturism. To be naked, in the reformed life of the adherents of "natural thinking," was to be free of the ballast of society. In their photographs, which provide a joyous variant on the theme of the open-air nude, the naked body is not unveiled in a slow ritual of seduction but simply bared. This tends to lead to the neutralization, the de-eroticization, of sexuality. By contrast, Ulrich Brendel wrote of Schiele in the magazine *Die Aktion* in 1916: "Few of the Moderns have so impressively given expression to the grandeur, but also to the frightening, vampiric side of sex."[33]

Turn-of-the-century Vienna may have had its "morality of silence and concealment," but sexuality was omnipresent. There is, of course, abundant evidence of the suppression of sex: in 1901, postcard reproductions of nudes by Rubens and Titian were confiscated on grounds of indecency. But this needs to be qualified in the light of the enormous amount of talk that went on about sexuality.

In discourse, the suppressed reappears. It is no coincidence that the decades on either side of 1900 witnessed a great increase in literature on sexual pathology, which investigated the sexual determinants of character, of the psyche, of the intellectual faculties, and of the

Gustave Courbet, *The Origin of the World*,
1866. Oil on canvas, 18 ⅛ x 21 ⅝ in.
(46 x 55 cm). Private collection

Auguste Rodin, *Salammbô*, ca. 1900
Pencil and stump on paper, 7 ⅞ x 12 ¼ in.
(20 x 31 cm). Musée Rodin, Paris

Opposite:
Female Nude with Folded Arms, 1909
Pencil and watercolor on paper,
17 ⅝ x 12 in. (44.8 x 25.9 cm).
Graphische Sammlung Albertina, Vienna

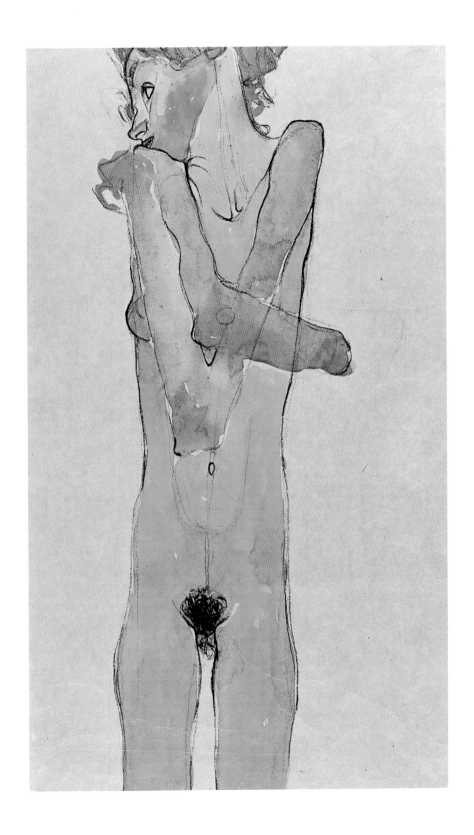

OTTO WEININGER

GESCHLECHT UND
CHARAKTER

EINE PRINZIPIELLE UNTERSUCHUNG

WILHELM BRAUMÜLLER VERLAG
WIEN–LEIPZIG

Cover of Otto Weininger's *Geschlecht und
Charakter* (first published in Vienna, 1903)

Opposite:
*Seated Female Nude, Elbows Resting on Right
Knee*, 1914. Pencil and gouache on paper,
19 x 12 ⅝ in. (48.3 x 32 cm). Graphische
Sammlung Albertina, Vienna

moral qualities, as well as the ever-recurrent question
of what was to be regarded as sexually morbid, perverse,
and punishable, and what was normal and healthy. Otto
Weininger's book *Geschlecht und Charakter* (Sex and
Character) appeared in 1903; Iwan Bloch's *Das Sexual-
leben unserer Zeit in seinen Beziehungen zur modernen
Kultur* (The Sexual Life of Our Time in its Relation to
Modern Culture) in 1908; in 1912, Bloch published
Die Prostitution. Dr. Magnus Hirschfeld's major work
on homosexuality and *Sexual Anomalies* (or, as the Ger-
man title has it, Sexual Transitions, *Geschlechtsübergänge*)
first appeared in 1905. There were other studies by
Albert Moll and Eduard Fuchs, as well as the *Psychopa-
thia sexualis* of Baron Richard von Krafft-Ebing, direc-
tor of the first university psychiatric clinic in Vienna
(1885) and Freud's *Drei Abhandlungen zur Sexualtheorie*
(Three Treatises on Sexual Theory, 1905).[34]

People were always working away at sexuality, in the
hope of provoking its disappearance. As Stefan Zweig
wrote in his autobiography:

> But the nineteenth century labored under the illusion that
> all conflicts could be solved by rationalization, and that the
> more we hid the natural, the more we could temper our
> lawless powers. Therefore, if young people were not en-
> lightened about the presence of these forces, they would
> forget their own sexual urges. . . . This dishonest and un-
> psychological morality of secrecy and hiding hung over us
> like a nightmare.[35]

It was no coincidence that psychoanalysis came into
being at a time when the suppression of natural im-
pulses was brought face to face with its own failure,
and with the mental illness that was the consequence
of that failure.

It is within this perceptual frame, one entirely typi-
cal of the age, that we should consider a subject already
taken up in the nude drawings of Klimt and Rodin: that
of a woman or a child masturbating. In 1904, Anna
Fischer-Dückelmann, author of a best-selling medical
handbook, entitled "The Housewife as Family Doctor,"
recommended on educational grounds that children
should not be allowed to wash their own sexual organs,
since this only led "to sexual stimuli." She went on:

> Educate girls and boys into true virtue by teaching them
> that touching the sexual parts is forbidden and ugly, and

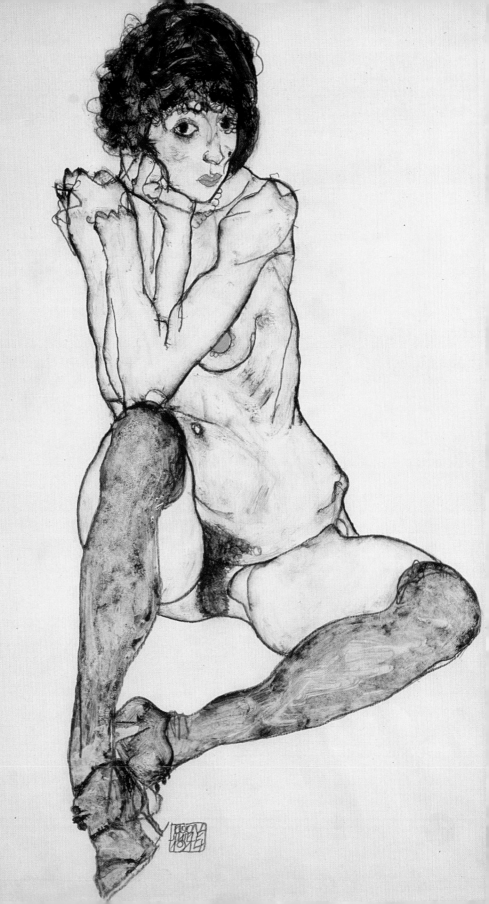

by insisting on a tone of purity in the home. A household thus conducted will produce people who are chaste and pure at heart. With children below the age of reason, see that they keep their hands above the bedclothes at night. . . . Children who masturbate are aberrant, but not criminal; often, unfortunately, they are already very sick.[56]

The fact is that people incessantly concentrated on child sexuality through the very fact of denying it. Children were watched, checked up on, tied up in bed, and punished. And, in this respect, even Freud's proof of the existence of infantile sexuality changed nothing.

Gustave Courbet, *Sleep*, 1866. Oil on canvas, 53 ¼ x 78 ¾ in. (135 x 200 cm). Musée du Petit Palais, Paris

Sex Crime as Artifact

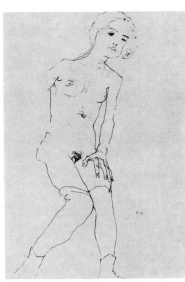

During what became known as the Neulengbach affair, Schiele was charged with abduction of a minor, sexual abuse, and "open outrage of public morals or decency." The twenty-two-year-old artist found himself face to face with the prevalent mechanisms of sexual repression, armed with all the majesty of the law. Heinrich Benesch told the story:

> Like his great colleague Klimt, Schiele was an erotic artist. He was extremely liberal in sexual matters. This might have been all very well with professional models, but not with children, whom he drew in the nude frequently and with pleasure. In so doing, he made no allowances for their innocence (if any). All this was certainly not done with any evil intent; it was sheer thoughtlessness and nonchalance. He never abused the children. . . . The accusation of "immorality" arose as follows. In his easy-going way, whenever he had finished drawing his child models, he often allowed whole hordes of other boys and girls, the models' classmates, to come into the room where he worked and play there. He had tacked up on the wall a wonderful colored drawing of a girl, nude from the waist down. Those of the children who were no longer innocent discussed it in whispers, told tales, and that was how Schiele came to be charged.[37]

Schiele was acquitted of abduction and child abuse, but he was convicted on the third count, the one described by Benesch, and sentenced to what was by current standards an extremely mild penalty. He was humiliated, and above all mystified, by the hypocritical indignation of the court at his nude drawing: "The adults—have they forgotten how corrupt they themselves were, how attracted and excited by sex, when they were children?"[38]

In Neulengbach, as earlier in Krumau, it certainly counted against Schiele that he and his girlfriend Wally (Valerie) Neuzil "lived in sin," thus offending against prevailing notions of morality, and also against public decency, as protected since 1900 by increased criminal penalties. In discussions of Schiele's expulsion from Krumau, it is often overlooked that the law of the land classified extramarital intercourse as an "immoral act" and "lewdness." The only distinction was between the lewdness that carried a legal penalty and the lewdness that did not; but even concubinage based on free, mu-

Semi-Reclining Nude Girl, 1910. Pencil on paper, 21 ⁷/₈ x 14 ⁵/₈ in. (55.7 x 37 cm). Landesmuseum Johanneum, Graz

Seated Nude Girl, Left Hand on Thigh, 1910. Pencil on paper, 22 x 14 ¹/₂ in. (55.8 x 36.8 cm). Leopold Museum, Privatstiftung, Vienna

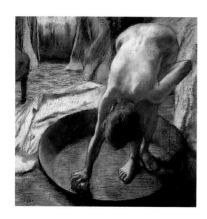

tual consent constituted an "immoral act" and might be punished as an offense against public decency.[39]

From Schiele's early nude drawings onward, the choice of type was related to the degree of shamelessness. For certain obscene poses, the only models available to Schiele were prostitutes or (on a related social level) proletarian women. To an extent at least, Schiele seems to have shared the hierarchical social values of his day. On 16 February 1916, when he told Roessler that he wanted to get married, he added: "as favorably as possible, not Wal maybe"—thus no doubt conveying to his friend that his current companion, Wally Neuzil, a former model of Klimt's, was ineligible. His eventual wife, Edith, the younger of the two Harms sisters, came from a bourgeois background, had been to convent school, and brought with her a dowry (albeit a modest one). Significantly, she demanded that he cut Wally out of his life not only as a girlfriend but as a model:

> What may happen later I don't care about now but I want to make a clean start to the marriage. I will not and shall not lay down any precepts for you. But you can understand the business with your girlfriend; from my point of view I am not asking anything impossible. I love you, but don't suppose that I am blindly in love and that it is my jealousy that demands the step with W. No, as I said, all I want is cleanness. I don't know whether you really understand what I mean. . . . You are supreme to me, and I will listen to you, do whatever you want, because I know you won't ask anything impossible of me, I mean anything that is beneath my dignity as a woman.[40]

In the early part of her married life, Edith herself was Schiele's only nude model; it was not until she put on weight, and no longer matched her husband's ectomorphic ideal, that other women were once again brought in to model for him.

Edgar Degas, *The Bath*, 1885-86. Pastel on paper, 27 $\frac{1}{2}$ x 27 $\frac{1}{2}$ in. (70 x 70 cm). Hill-Stead Museum, Farmington, Connecticut

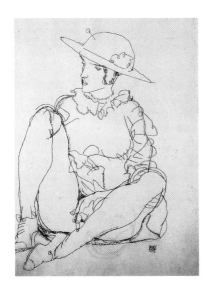

Change of Position

After the Neulengbach affair, Schiele drew no more child nudes, except on one occasion when he worked with a professional model and her daughter. The female nude, too, diminished in importance for a time, both quantitatively and qualitatively. Above all, however, his subsequent nudes display one striking new compositional feature: an exaggerated use of perspective, with a viewing angle that shifts from one drawing to the next. In 1913 he painted a series of standing seminude figures, in one of which the shoulders and upper torso are outside the field of view; the sight line runs from the eye-height of a standing person down onto the model's feet. The canvas and the visual field coincide exactly.

Of Schiele's three great predecessors in the field of erotic drawing—Edgar Degas, Rodin, and Klimt—the two last-named share with Schiele the isolation of the figure, the absence of any spatial context. Where Degas's women wash themselves in bathtubs and basins in the most varied poses, in Rodin there is the same absence of a spatial setting as in the two Viennese artists. The high degree of abstraction in Rodin's nude drawings means that their nonlocality is never an issue. With a swift pencil stroke, the outline of the woman is captured; the watercolor is added later, and is equally loose, so that the absence of detail in the drawing of the nude tallies with the absence of any indication of place.

Degas, by contrast, finds an external motivation for the attitudes of his models; he looks at them from different viewpoints, all of which—as Eunice Lipton has shown—can only be the viewpoints of a male visitor to a brothel. All the girls and women washing themselves in these drawings are prostitutes.[41] It is hard to appreciate nowadays that Degas's nudes were once regarded as ugly and cruel—and equally hard to understand J.-K. Huysmans' assertion that Degas observed the women in abject, humiliating postures as they went about their intimate concerns. Félix Fénéon, too, spoke of Degas's women as ugly; by which he meant that to him, as an art critic, their unidealized poses, derived spontaneously from the act of washing, were unaesthetic.

Even where Degas, in a back view, most completely dispenses with the identification of the interior, he justifies the forward-leaning posture—unprecedented in the entire iconography of the nude—by reference to

Auguste Rodin, *Female Nude* (no date)
Pencil and watercolor on paper, 12 ⅞ x 6 in.
(32.7 x 15.3 cm). Musée Rodin, Paris

Seated Girl with Hat, Masturbating, 1913
Pencil on paper, 19 ⅛ x 12 ¾ in.
(48.6 x 32.4 cm). Private collection

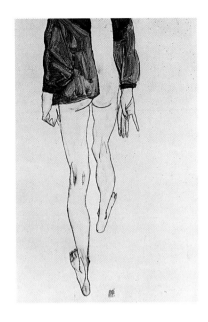

the activity of washing. Intimate though it may be, we take the process of washing oneself, arranging the hair, drying oneself, so much for granted—it seems such a familiar element of the daily routine—that we need the social historians to reconstruct the context for us before we can appreciate the piquancy of Degas's nudes: the fact that they are all studies of prostitutes in a brothel.

By contrast, it is clear that Klimt's women are defined, through and through, in terms of their sexuality. Eduard Fuchs, the author of a history of erotic art, realized this at the turn of the century: "When Gustav Klimt draws a female nude, he always emphasizes the genital sphere. Often very tenderly and delicately, but even then quite unmistakably, in such a way that the eye is drawn to the spot. And in any picture, the point on which the viewer's eye involuntarily falls is the point on which the artist concentrated with particular intensity as he worked."[42]

Although Klimt's depictions of lesbians and of women copulating or masturbating are always dictated by the gaze of the male artist, by his pictorial strategy and his agenda, these works have seldom been analyzed from the standpoint of the male who staged them or of the male viewer.[43] Klimt's nude drawings have tended to be regarded as the liberating expression of autonomous, self-defining female sexuality. It is no doubt primarily the psychological expression of self-forgetfulness that promotes the emotional detachment of Klimt's subjects from the artist and thus from the male viewer. Their eyes are mostly closed; they look at no one; they seem to exist by themselves alone and for their own pleasure.

This illusion, that pleasure depicted exists in isolation from the artist who depicts it, is one that Schiele abolishes through his forced emphasis on the model-viewer relationship. Where Klimt's models hardly ever catch the voyeur's eye, Schiele's women give us an unblinking stare. The viewer of Schiele's nudes is not really a voyeur at all; the situation staged by Schiele, that of modeling in his studio, has nothing secret about it. Of course, both—Klimt as well as Schiele—have the model's body at their entire disposal. Sleeping or moving, suffering or rejoicing, alluring or alarming, ecstatic, whole, or cropped, the body relies on the artist to present it and dress it, to create symbolic or real environments for it. The artist is omnipresent. But in Klimt's drawings he conceals himself behind his own

Standing Seminude with Brown-Green Vest, Back View (Torso), 1913. Pencil, watercolor, and gouache on paper, 18 3/8 x 12 5/8 in. (46.7 x 32 cm). Private collection

Opposite:
Striding Torso in Green Blouse, 1913 Pencil, watercolor and gouache on paper, 19 x 12 1/2 in. (48.2 x 31.7 cm). Private collection

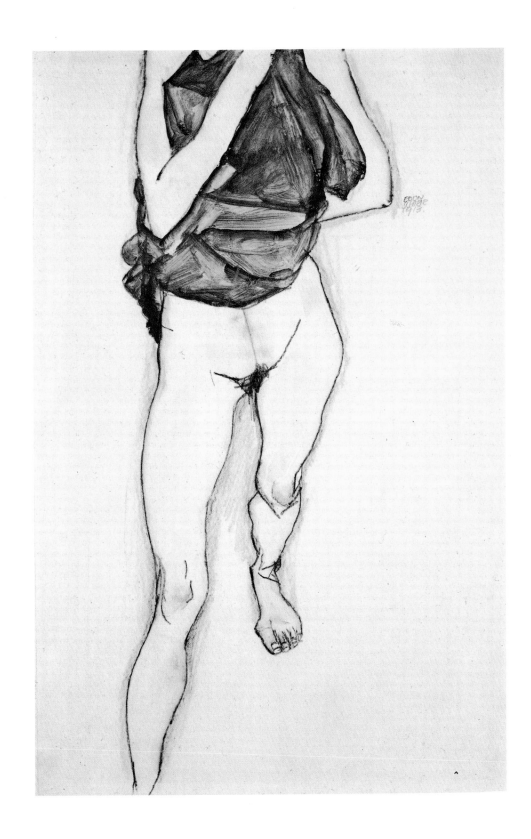

Gustav Klimt, *Seated Woman, Thighs Open*, 1916-17. Pencil and red crayon with white heightening on paper, 22 ½ x 14 ¾ in. (57 x 37.5 cm). Private collection

Opposite:
Schiele, *Drawing a Nude Model before a Mirror*, 1910. Pencil on paper, 21 ¾ x 13 ⅞ in. (55.2 x 35.3 cm). Graphische Sammlung Albertina, Vienna

pictorial idea, and behind the fantasy of secretly eavesdropping on an erotic act; in Schiele, the artist is always there. Not only the portraits but the nudes, even the back views, react with and offer themselves to the viewer. In Schiele's portraits the ideal of dialogue can be fended off by hellish grimaces, but is always present through its very negation; similarly, in the drawings the exaggerated perspective, the striking angle of sight, which situates every viewer of a Schiele drawing in a specific location, defines the active relationship between artist and model.

The way in which Schiele's nudes invariably relate to the viewer is something they share with those photographs that the English, with lordly reticence, describe as "left-hand pictures": masturbation material. Other features that the drawings and watercolors have in common with under-the-counter photographs are their varied poses and even (in the early part of Schiele's career) their predilection for child nudes. All in all, the role of the so-called low arts of caricature, and especially of erotic and pornographic photography, should not be overlooked in the genesis of Schiele's nudes. With a few exceptions based on erotic paintings—notably Gustave Courbet's *The Origin of the World*—the audacious poses of Schiele's models have their precedents in cheap, mass-produced erotic photographs. This genre, initially legitimized under the heading of "study" material for artists, was classified as indecent from the 1870s onward because it had blatantly departed from the canon of academically sanctioned poses.

Fundamentally, the dynamic of the shifting viewpoint—which barely appears in Klimt, Munch, or Rodin but is prefigured in Degas—points toward working in series. Just as Schiele, in 1910-11, was constantly trying out new grimaces on his own face, from 1913 or 1914 he tried out new poses and postures. The transition from set naturalness of expression to mugging had its counterpart in the constant changes of pose, the numerous postures, that the models had to adopt. However, the repertoire of grimaces was as limited as that of postures was varied. The relative multiplicity of both cannot be adequately covered except by working in series. This in itself was something that Schiele never attempted—although a glance through Jane Kallir's *catalogue raisonné*, which is arranged by motif, will confirm that his individual images approximated to a serial

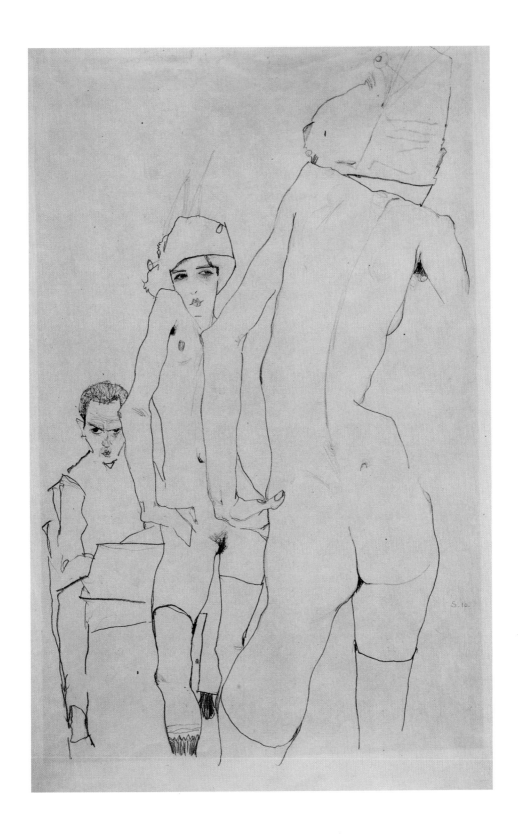

Edgar Degas, *The Bath*, 1886. Pastel,
23 ½ x 32 ½ in. (60 x 83 cm).
Musée d'Orsay, Paris

pattern.[44] In this respect, his closest affinity is with Rodin, who also liked to play with image-cropping and angled shots. This cinematic thinking allied itself with the inquisitive compulsion to see the body from every side: the view from above as against the view from below, the sideways pan, the mirror shot. From one drawing to the next it is as if the body is filmed, piece by piece.

Whereas contemporaries said of Degas's models that they were in unforced poses, the stereotyped poses of Schiele's models signal the relative limitations that he placed on the self-determination of the women, and thus their limited freedom to behave as they wished. The autonomy of the models is limited by the usability of the motif that they provide. Degas, too, undoubtedly dictated his poses. But because he observed his women during the intimate and domestic moments of their toilette, he created the illusion that each was by herself, alone with herself. *Mutatis mutandis*, the same applies to Henri de Toulouse-Lautrec's depictions of nude or seminude prostitutes.

Schiele makes the process of observation his theme, by giving thematic status to the observer. In his contrived perspective, the directionality of the artist's gaze—and of the viewer's, however many decades later—is reestablished every time. Once we have recognized Schiele's unique assertion of the untrammeled prerogative of the artist's eye—even at the expense of the autonomy of what is seen—it is worth looking at one residual motive for the endless variations of his liberated act of seeing.

Ever since the dialogues of Plato, the sense of sight has been granted a special position in relation to the other senses: it alone is capable of seeing the essence of things. This is a distinction that it must constantly earn anew, through good behavior and through independence from the demands of the body. In the nineteenth century the eye rose to new honors as a result of its alleged scientific incorruptibility. But there was no excuse for the curiosity of the eye when it directed itself at objects protected by a taboo.

In an article published in 1894, Norbert Grabowsky coupled sexuality with the sensual enjoyment that interferes with the acquisition of knowledge: "It is in everyone's enlightened self-interest, which all should pursue, to practice abstinence. In an obscure and mysterious way, he who gives himself to woman more,

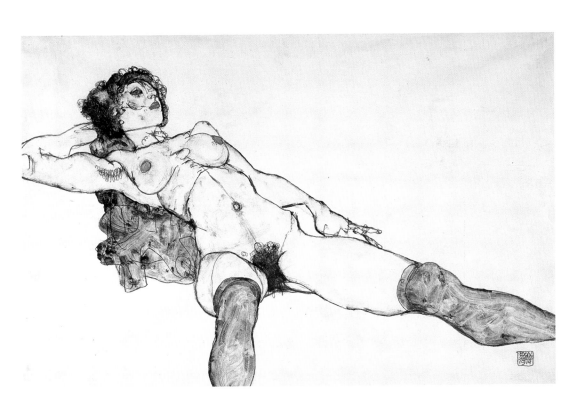

Reclining Female Nude with Legs Spread Apart,
1914. Pencil and gouache on paper,
12 x 18 ⅝ in. (30.4 x 47.2 cm).
Graphische Sammlung Albertina, Vienna

loses the ability to think metaphysically, to become aware of his higher self. All sensual enjoyment is the enemy of knowledge."[44]

Schiele's eye negates all such demarcations. True, the sheer mobility of his visual sense cannot be justified in terms of the Mannerist precept "equally beautiful from every side," because the object that he is examining from every side makes a mockery of contemporary ideas of beauty. But it remains true that in Schiele's work visual enjoyment transcends the opposition between sensual arousal and aesthetic perception.

List of Plates

Notes

1 Ludwig Marcuse, *Obszön: Geschichte einer Entrüstung* (Zurich, 1984), 11.

2 Arthur Roessler, quoted in Christian M. Nebehay, *Egon Schiele 1890-1918: Leben, Briefe, Gedichte* (Salzburg, 1970), 171.

3 Arthur Roessler, "Egon Schiele," *Bildende Künste*, no. 3 (Leipzig, 1911), 104ff.

4 Anton Räderscheidt, journal, October 1966, quoted by Günter Herzog, "Anton Räderscheidts Selbstbetrachtungen," in Werner Schäfke and Michael Euler-Schmidt, eds., *Anton Räderscheidt* (Cologne, 1993), 21.

5 Richard Gerstl, *Selbstbildnis als Akt in ganzer Figur*, 1908. Vienna, Museum Stiftung Leopold. On Gerstl, see Klaus Albrecht Schröder, *Richard Gerstl 1883-1908* (Vienna, 1993), esp. 12ff.

6 Søren Kierkegaard, *Either Or: A Fragment of Life*, trans. and ed. Alastair Hannay (London and New York, 1992), 43.

7 Albert Paris Gütersloh, *Egon Schiele* (Vienna, 1911), quoted in Christian M. Nebehay, *Egon Schiele: Leben und Werk* (Salzburg, 1980), 100f.

8 Nebehay (as note 2), 176f.

9 Rudolf Leopold, *Egon Schiele: Gemälde, Aquarelle und Zeichnungen* (Salzburg, 1972), 212.

10 Egon Schiele, letter quoted in Leopold (as note 9).

11 Johann Caspar Lavater, *Physiognomische Fragmente zur Beförderung der Menschenkenntnis und Menschenliebe* 1 (1775), 62.

12 On two occasions, Patrick Werkner has taken up these points, first made by myself in December 1992, and corrected his original linkage of Schiele's body language with dance. He continues, however, to misunderstand the sense of the artistic interpretation of pictures by the mentally ill. See Patrick Werkner, *Physis und Psyche: Der Österreichische Frühexpressionismus.* (Vienna and Munich, 1986); "The Child-Woman and Hysteria: Images of the Female Body in the Art of Schiele, in Viennese Modernism, and Today": in Patrick Werkner, ed., *Egon Schiele, Art, Sexuality and Viennese Modernism* (Palo Alto, 1994), 50ff; and Patrick Werkner, "Frauenbilder der Wiener Moderne und ihre Rezeption heute", in Klaus Amann, Armin A. Wallas, eds., *Expressionismus in Österreich: Die Literatur und die Künste* (Vienna, Cologne, and Weimar, 1994), 138ff.

13 R.R., exhibition review, *Illustriertes Wiener Extrablatt*, 1918, quoted in Nebehay (as note 2), 457, no. 1419.

14 Quoted in Nebehay (as note 2), 164, no. 172.

15 Werner Hofmann, "Das Fleisch erkennen?," in Alfred Pfabigan, ed., *Ornament und Askese: Im Zeitgeist des Wien der Jahrhundertwende* (Vienna, 1985), 126.

16 All quoted in Rainer Fuchs, *Apologie und Diffamierung des "österreichischen Expressionismus": Begriffs- und Rezeptionsgeschichte der österreichischen Malerei 1908-1938* (Vienna and Cologne, 1991), 52-54.

17 Albert Paris Gütersloh, *Versuch einer Vorrede* (Vienna, 1911), reprinted in Arthur Roessler, ed., *In memoriam Egon Schiele* (Vienna, 1921), 24.

18 Georg Simmel, *Philosophie des Geldes*, quoted in Hartmut Scheible, *Literarischer Jugendstil in Wien* (Munich and Zurich, 1984), 11.

19 Kolo Moser, *Selbstbildnis*, 1916. Vienna, Österreichische Galerie.

20 Oskar Kokoschka, *Bildnis Auguste Forel*, 1910. Mannheim, Städtische Kunsthalle.

21 Guillaume-Benjamin-Armand Duchenne, *Mécanisme de la physiognomie humaine ou Analyse électrophysiologique de l'expression des passions* (Paris, 1876), 13, quoted by Elisabeth Madlener, "Die physiognomische Seelenerkundung," in Jean Clair, Kathrin Pichler, and Wolfgang Pircher, eds., *Wunderblock: Eine Geschichte der modernen Seele* (Vienna, 1989), 173.

22 Jules Falret, quoted in Manfred Schneider, "Hysterie als Gesamtkunstwerk," in Pfabigan, ed. (as note 15), 223.

23 Peter Altenberg, "Die Schwestern Wiesenthal, Tänzerinnen," quoted in Grete Wiesenthal, *Die Schönheit der Sprache des Körpers im Tanz*, eds. Leonhard Fiedler and Martin Lang (Salzburg, 1985), 69.

24 Karl Rosenkranz, *Ästhetik des Häßlichen* (Königsberg, 1853; undated reprint), 8.

25 Ludwig Hevesi, *Das verruchte Ornament* (1903), quoted in Otto Breicha, ed. *Gustav Klimt—Die Goldene Pforte: Werk, Wesen, Wirkung: Bilder und Schriften zum Leben und Werk* (Salzburg, 1978), 117.

26 Roessler (as note 3), 114.

27 Jean Paul, *Vorschule der Ästhetik* 3.2.

28 Max Scheler, "Über Scham und Schamgefühl" (1913), in Scheler, *Schriften aus dem Nachlaß* 1 (Berlin, 1933) 76.

29 Rosenkranz (as note 24), 235.

30 Nebehay (as note 2), 459, no. 1443.

31 Karl Kraus, *Die Fackel*, no. 155, 24 February 1904, 8.

32 Recorded by the celebrated actress Tilla Durieux in her memoirs, *Eine Tür steht offen: Erinnerungen* (Berlin, Munich, and Vienna, 1964), 5. This educational principle went along with total ignorance: "It goes without saying that all sexual questions were utterly taboo. Children were brought by the stork or by an angel, according to preference, right up to the moment when one was married and in a position to know better." (Ibid.).

33 Quoted in Nebehay (as note 2), 390.

34 Otto Weininger, *Sex and Character* (London, 1906). Iwan Bloch, *The Sexual Life of Our Time in its Relation to Modern Civilization* (London, 1908). Iwan Block, *Die Prostitution* (Berlin, 1912). Magnus Hirschfeld, *Sexual Anomalies and Perversions* (London 1946; rev. ed. London 1952). Richard von Krafft-Ebing, *Psychopathia Sexualis* (Philadelphia and London, 1892). Sigmund Freud, *A Case of Hysteria, Three Essays on Sexuality, and other Works*, trans. and ed. James Strachey et al. (London 1953).

35 Stefan Zweig, *The World of Yesterday: An Autobiography* (New York and London, 1943), 62-63.

36 Anna Fischer-Dückelmann, *Die Frau als Hausärztin: Ein ärztliches Nachschlagewerk* (Berlin, 1904), 783.

37 Heinrich Benesch, *Mein Weg mit Egon Schiele*, ed. Eva Benesch (New York, 1965), 24ff.

38 Quoted in Jean-Michel Palmier, "Träume um Egon Schiele," in Wolfgang Pircher, ed., *Debüt eines Jahrhunderts: Essays zur Wiener Moderne* (Vienna, 1985), 141. The entries in the artist's prison journal, as published by Arthur Roessler, the art critic of the *Arbeiter-Zeitung*, have been shown to be spurious in parts, though they seem largely to reflect Schiele's thoughts and attitudes.

39 On this see Regina Schulte, *Sperrbezirke: Tugendhaftigkeit und Prostitution in der bürgerlichen Welt* (Frankfurt am Main, 1979), 162ff., who also gives the relevant extracts from criminal law codes and commentaries.

40 Nebehay (as note 2), 190.

41 Eunice Lipton, *Looking into Degas: Uneasy Images of Women and Modern Life* (Berkeley, 1986), 165ff.

42 Eduard Fuchs, *Geschichte der erotischen Kunst: Das individuelle Problem*, II (Berlin, 1977), 270.

43 See Gottfried Fliedl, *Gustav Klimt* (Cologne, 1989).

44 Jane Kallir, *Egon Schiele: The Complete Works* (New York, 1990).

45 Norbert Grabowsky, *Die geschlechtliche Enthaltsamkeit als sittliche Forderung* (1894), quoted in Oskar Panizza, "Die sexuelle Belastung der Psyche als Quelle künstlerischer Inspiration," *Wiener Rundschau*, no. 1. 15 Feb. 1897, 350.

Front cover: *Seated Nude*, 1911,
Leopold Museum, Privatstiftung, Vienna
Back cover: *Self-Portrait*, 1910,
Leopold Museum, Privatstiftung, Vienna

Frontispiece: *Egon Schiele*, 1914,
Photo by Anton J. Trčka
Page 4: *Nude on Colored Fabric*, 1911,
Private collection

Translated from the German by David Britt
Copyedited Sheila de Vallée

© Prestel-Verlag, Munich and New York 1995

Prestel-Verlag
Mandlstrasse 26, D-80802 Munich, Germany
Tel. (89) 38 17 09-0; Fax (89) 38 17 09-35
and 16 West 22nd Street, New York, NY 10010, USA
Tel. (212) 627 81 99; Fax (212) 627 98 66

Prestel books are available worldwide. Please
contact your nearest bookseller or write to
either of the above addresses for information
concerning your local distributor.

Typeset by Wigelprint, Munich
Lithography by ReproLine, Munich
Printed and bound by Passavia Druckerei GmbH, Passau
Typeface: Gill Sans and Janson Text

Printed in Germany

ISBN 3-7913-1383-5 (English edition)
ISBN 3-7913-1393-2 (German edition)